The Lucayans

story by
Sandra Riley

paintings by
Alton Lowe

MACMILLAN

First published 1991

Published by MACMILLAN EDUCATION LTD
London and Basingstoke
Associated companies and representatives in Accra, Auckland, Delhi, Dublin, Gaborone, Hamburg, Harare, Hong Kong, Kuala Lumpur, Lagos, Manzini, Melbourne, Mexico City, Nairobi, New York, Singapore, Tokyo.

Printed in Hong Kong

British Library Cataloguing in Publication Data
Riley, Sandra
The Lucayans
I. History, Social Life
I. Title II. Lowe, Alton
972.9843

ISBN 0–333–53967–2
ISBN 0–333–53933–8 pbk

Photographs of the author and the artist on the back cover by Dianne Machado

Other books by Sandra Riley
The Captain's Ladies (a novel)
Homeward Bound: A History of the Bahama Islands to 1850
Sometimes Towards Eden (a novel)

Acknowledgements

Alton Lowe and I extend our thanks to the following people for their advice, assistance and support: Liz Basile, Mary Jane Berman, Dan Blackmon, Brotherhood of Life (Albuquerque, New Mexico), Mike Donovan, Don and Kathy Gerace, Gotthard Bank, Julian Granberry, Terry and Barbara Herlihy, Charles Hoffman, Sr. Dorothy Jehle, Little, Brown and Co., Eugene Lyon, Dianne Machado, Vanessa Magnanini, Anubis Pérez, Cecilia Rennella, Miriam Rosen, John Saunders, Jim and Virginia Schrenker, Oscar Seiglie, Joe Shi and John Winter. And we would like to thank Farrar, Strauss and Giroux, Inc for their permission to reprint an adaptation of a section from *The Red Swan: Myths and Tales of the American Indians* edited by John Bierhorst, © 1976.

I wish to thank the Otto G. Richter Library of the University of Miami for allowing me to use these rare books to compile the *Glossary of Indian Words*.

Bachiller y Morales, Don Antonio. *Cuba Primitiva: Origen, Lenguas, Tradiciones e Historia de los Indios de las Antillas Mayores y las Lucayas.* Habana, 1883.

Zayas y Morales, Alfredo. *Lexicografía Antillana: Diccionario de Voces Usadas por los Aborígenes de las Antillas Mayores y de Algunas de las Menores y Consideraciones Acerca de su Significado y de su Formación.* Habana, 1914.

My deepest gratitude to Bárbara Magnanini and Anubis Pérez for translating the sometimes difficult Spanish of these dictionaries.

I am particularly grateful to Robert Carr, Peggy C. Hall, Bárbara Magnanini, Sue Nelson and Margie Salem.

List of paintings and acknowledgements

Men from Heaven (page 1) Detail. Courtesy Gotthard Bank.
Nature's Pilots (page 2) Detail. Courtesy Gotthard Bank.
Lucayan Vessel (page 4) Courtesy Gotthard Bank.
Rocky Shore (page 6) Courtesy Iris Lowe Powers.
Lucayan Village (page 8) Courtesy Gotthard Bank.
The Potters (page 10) Courtesy Gotthard Bank.
Emergence (page 14) Courtesy Orville Turnquest.
Spirit of the Waters (page 16) Courtesy Gotthard Bank.
Encyclia Hodgeana (page 18) Courtesy Joe and Millie Lleida.
The Fishers (page 19) Courtesy Gotthard Bank.
The Fishers (page 20) Detail. Courtesy Gotthard Bank.
Bahamian Parrot (page 21) Detail. Courtesy Dr. Ulrich Baench.
Lucayan Traders (page 22) Detail. Courtesy Gotthard Bank.
Men from Heaven (page 22) Detail. Courtesy Gotthard Bank.
Bahamian Parrot (page 24) Detail. Courtesy Dr. Ulrich Baench.
High Cay, Guanahaní (page 25) Courtesy Mel Schenweather.
Bahamian Parrot (page 29) Courtesy Dr. Ulrich Baench.
Cliffs of Ziguateo (page 30) Courtesy the artist.
Night Sun (page 33) Detail. Courtesy Gotthard Bank.
Cattleyopsis Lindenii (page 35) Courtesy Joe and Millie Lleida.
Lucayan Sunset (page 37) Courtesy Curtis and Ginny Curry.
Lucayan Village (page 38) Detail. Courtesy Gotthard Bank.
Night Sun (page 39) Detail. Courtesy Gotthard Bank.
Night Sun (page 41) Courtesy Gotthard Bank.
Night Sun (page 42) Detail. Courtesy Gotthard Bank.
Encyclia Lleidae (page 43) Courtesy Joe and Millie Lleida.
Night Sun (page 44) Detail. Courtesy Gotthard Bank.
Night Sun (page 46) Detail. Courtesy Gotthard Bank.
Discovery (page 51) Detail. Courtesy Gotthard Bank.
Men from Heaven (page 52) Courtesy Gotthard Bank.
Discovery (page 55) Courtesy Gotthard Bank.
Nature's Pilots (page 57) Courtesy Gotthard Bank.
Lucayan Traders (page 59) Courtesy Gotthard Bank.
Thanksgiving (page 61) Courtesy Gotthard Bank.
Columbus Monument, San Salvador (page 62) Courtesy Gotthard Bank.
Thanksgiving (page 73) Detail. Courtesy Gotthard Bank.

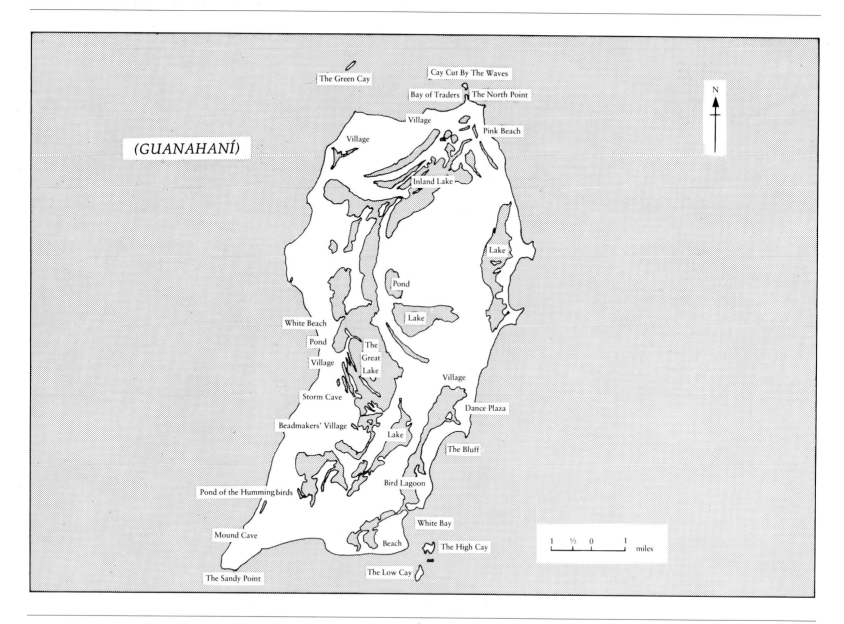

(GUANAHANÍ)

The Green Cay

Cay Cut By The Waves

Bay of Traders The North Point

Village

Village

Pink Beach

Inland Lake

Lake

Pond

Lake

White Beach

Pond

Village

The Great Lake

Village

Storm Cave

Dance Plaza

Beadmakers' Village

Lake

The Bluff

Bird Lagoon

Pond of the Hummingbirds

White Bay

Mound Cave

Beach The High Cay

The Sandy Point

The Low Cay

N

1 ½ 0 1 miles

Author's Preface

During my fifteen years of research on Bahamian history, I came to realize that the Lucayan view of the universe was very different from the European. That is why the clash of cultures experienced during the contact period must have been more difficult than anyone will ever know and, in light of the ultimate extermination of the Indians, worse than imagination could conceive.

Like all pre-historic peoples, the Lucayans saw no separation between their physical and spiritual worlds. The three characters in my novella are shamans and as such can move freely among the strata of the universe. They can leave their physical bodies behind, take other shapes, if they so choose, or travel with their astral bodies. The Boy has a vision quest, an archetypal journey, a rite of passage.

The Lucayans trusted their intuition and understood simultaniety of time. To illustrate the working of the concept of time in the novella, I have the narrator use the present tense. The narrator is the collective representative of the Lucayan people, and uses an economy and simplicity of language to communicate. In researching the book, I tried to immerse myself in the Lucayan culture, to assimilate every part of it so that in the writing I could allow a presence to manifest as the narrator.

Since this is a fictionalized history, you may want to read the material at the back of the book before reading the novella or at least learn what information is contained there. I have included an historical note, an explanation of the visual symbols and the places referred to in the book and a glossary of the Arawak (Indian) words. Some of the Indian words form a part of the English language; all are italicized in the text.

The novella is designed to be read in one sitting. Be patient as you read the first few pages. On a conscious level, you will experience the feelings and sensory images. On an unconscious level you will understand the symbols and archetypes.

Sandra Riley
26 August 1989
Miami, Florida

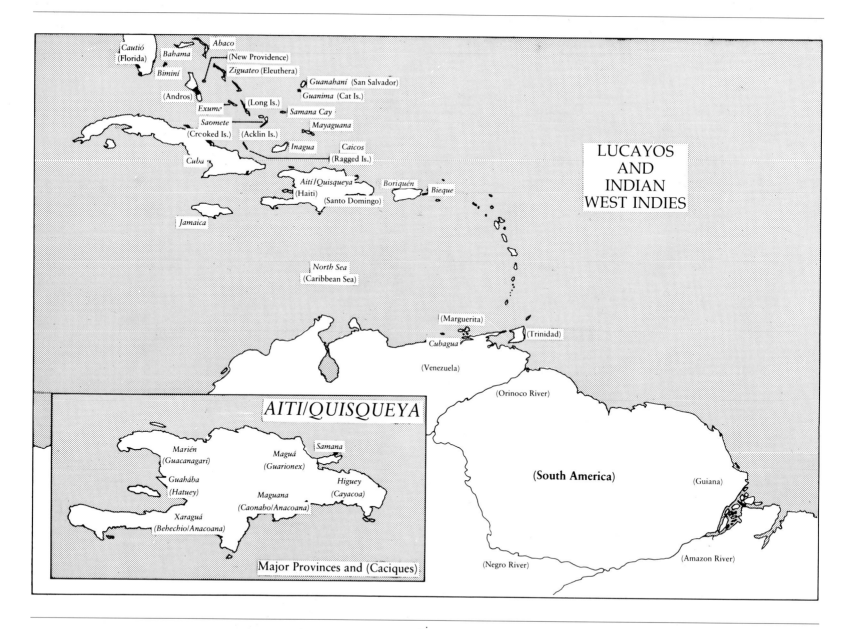

Cautió
(Florida)

Bahama

Abaco

Bimini

(New Providence)

(Andros)

Ziguateo (Eleuthera)

Guanahaní (San Salvador)

Guanima (Cat Is.)

Exume

(Long Is.)

Saomete

Samana Cay

(Crooked Is.)

Mayaguana

(Acklin Is.)

Inagua

Caicos

(Ragged Is.)

Cuba

Aití/Quisqueya

Boriquén

Bieque

(Haiti)

(Santo Domingo)

Jamaica

North Sea
(Caribbean Sea)

LUCAYOS
AND
INDIAN
WEST INDIES

(Marguerita)

(Trinidad)

Cubagua

(Venezuela)

(Orinoco River)

AITI/QUISQUEYA

Marién
(Guacanagarí)

Maguá
(Guarionex)

Samana

Guahába
(Hatuey)

Higuey
(Cayacoa)

Maguana
(Caonabo/Anacaona)

(South America)

(Guiana)

Xaraguá
(Behechio/Anacaona)

(Negro River)

(Amazon River)

Major Provinces and (Caciques)

To the spirit of the *Lucayos.*

*"That which hath been is now; and that which is to be hath
already been" Ecclesiastes 3:15*

Early Sun

From the sea cliff Father watches.

The Boy's eyes are closed. The Girl paints his body.

A butterfly.

Colors form shapes. A circle.

 A square. Four angles.

 A snake. Three Corners.

Spirals stretching outward.

 Spirals reaching inward.

He feels the early sun, smells the earth, hears the builders, tastes the sky. He brings life to the water. Our Father sees our goings and our comings.

Time. All time. No time.

The Boy drives one foot into the pink-white sand. Time and time again. The Girl's childlike fingers dip red. She traces the longest one down his spine to its root to linger there sliding back and forth like the stroke of a parrot feather. He shivers. Her palms spread black over his hard thighs inside and outside. On his flattened forehead white lines west to east cut across white lines north to south. Through the middle and at the top submerge into the dark dark blue, submerge our Mother, Land of the Sun, Land of the West.

His body quakes like the leaves of the red trunk tree in a storm. Now it begins. His sinews tear. His torso rises and falls like waves in the ocean. His spirit hurls into the sky. He is gone.

Squatting on her heels the Girl waits for his return. He is far away and all is quiet. A rushing wave touches the shore,

dry sea grasses scurry along the sand. A red crab scratches near the Boy, but he is far away. His screams are lost among the screams of thousands heaved into the fiery air, crushed below tons of stone, drowned in the timeless sea.


 water
 the
 above
 lifts
 sun
 The


She covers his body with the leaves of the sea grape. A tear drops. She draws a circle on his heart. On the rib below she paints a second circle with a white line from north to south through it. Under his rib she paints another circle and with deep strokes sets two north-south lines.

We begin.

His body jumps as a fish does when it first tastes the bone hook. Tears stiffen in the sea breeze. A smile breaks as she hurls her laughing face into the sun. Prone on his body she listens to the whispers of his breathing. Her stained white breasts feel his heartbeat grow stronger. She weaves her fingers into his and listens.

His pounding heart becomes the thundering reef.

Do I dream? she wonders. No. I am in the sea and very near the reef. Why does he do this to me with no warning? Why do I take his hand?

He sweeps her away from the fire corals and into a feathery bar. Light plays with color. She reaches after the small vibrant fishes. The sun falls into the water and pours over her face. She darts in spurts of elation. They float. Her right hand locks in his left.

Under the water her hand looks large. Her laughing face sustains him, but he often thinks of her hands. A child's hand on a woman's body. A soothing hand, yet strong. Strong enough to hold him when he feels himself split. She gathers the pieces of him like corn. A hummingbird has hands like these, he thinks. Small. Quick. Strong.

She touches a filmy creature. It is breathing with its whole body as she does when she is underwater with him. Yet drifts away from him and her throat becomes the burning of a thousand cooking fires. She thinks. I want to feel that. I try to pull my hand out of his grip to see what he does now. A great cliff bird holds me, I cannot break away. I frighten him, I think. I know he frightens me when he goes away without me. When he goes and leaves his body with me. My spirit flies when he takes my hand. I want to go to the great island to the west under the oceans in the sky where we gather herbs and flowers. So many colors, so many plants — all watery green. The sun does not burn them like here. Why, I wonder? And the light is like the setting sun all the day. Why? I will ask Father. He knows.

A
 sudden
 drop

Atop a white cliff the man they call Father, with arms outstretched, lifts into the air. As a great bird he hovers over the circle of deep blue in the green-white sea.

The ring of light at the water's surface is high above them now. Like a whorl they spiral down — sinking — falling.

Let go of fear, his touch tells her. This is not death. Shake off death. He looks up. Only a speck of light, smaller than a grain of sand, remains. She seems calmer now.

Her hand on his forehead tells him — no more words.

His life-giving force enters her life-nurturing place. In the deepest darkest watery tomb they create life.

Raising her left hand, she ascends, dragging his lifeless form. Now there is life inside her. She cannot follow him. The pull from above is strong, the weight of him cannot carry her down.

He wills to die now. Dark and cold. Let go and fall into the everlasting.

Light widens and spreads its mantle over them. Pink-white like the seed of the conch.

Her hand breaks the surface and is clutched by the claw of the great bird. They soar and dive and spin then descend — floating to the shore.

The Boy falls into Father's arms.

"Bring us water."

Leaving the Boy and Father on the white beach facing the western ocean, she runs into the sun and wind to the village.

A cup of water. It is a simple request. Bring water to bring back life. A twig breaks under her foot, lizards scramble in the bush. What vessel to use? A gourd? A clay cup? What size? What shape? What pattern? What magic colors?

Be quiet and listen. A voice shouts in her head.

The morning sun enters Father's hut placed where two rows of houses cross. Shadows dance on the reedy wall. Flat on a limestone shelf the vessel sits — a shore bird perched atop two small gourds. Its beak pecks the earth.

He is this vessel. I am this vessel. I can give life back to him.

At the pond beyond the village, she pushes the vessel into the standing sweet water and feels herself fill up.

14 February 1492 Castile

The mass is beginning.

Judica me, Deus, et discerne causam meum de gente non sancta. . . .	Judge me, O God, and distinguish my cause from the nation that is not holy. . . .

I am on my knees as I have been since Your Majesties received the seed of my plan to reach the Indies by sailing west. I pray my enterprise will grow nourished by your favor as you prosper in the favor of Rodrigo Borgia, Alexander VI, our Pope.

The priest is lifting the chalice and making the sign of the cross with it. Unworthy though I am, I must prepare to receive the Body and Blood of Our Lord and Savior Jesus Christ.

Sanguis Domini nostri Jesu Christi custodiat animam meam in vitam aeternam. Amen.	The Blood of our Lord Jesus Christ preserve my soul unto life everlasting. Amen.

Cristóbal Colón

Father receives the vessel and with both hands raises it to the sky. He sprinkles a few drops onto the sand, then dips the tail of the bird into the Boy's mouth. Laying a hand on the Boy's heart he waits.

She takes up the vessel, plies the gourds to warm the earth's blood. Blowing across the opening, her rich, deep note summons his spirit.

Body warms. Breath quickens. Blood drips through the fingers of his right hand onto the sand. A gash spreads across his palm from wrist to forefinger.

She drops the vessel.

The old man opens his eyes, the Boy his. His smile drains as he looks at his bleeding hand, then his eyes quicken, scanning his memory for a lost dream.

"Girl, take up his hand."

"My hands fill with blood."

"Scatter the blood in the Four Pathways. Boy, heal yourself."

"I cannot. It is too deep."

"A coral cut. Nothing more."

There is something more, he thinks. A long shining object, sharp, thin and bright flashes in his mind.

"Clear your thoughts." Father brushes his palm across the Boy's flat brow. Taking the injured hand, he pours what is left of the water over it. They watch the bloody gash close. "Heal yourself. You know how to do that. I am not always with you."

"But you are, Father. Even high on the cay cut by the waves you are with us."

Father places the Boy's hand in the Girl's hand. "Deep in the dark blue waters of the ocean hole the Great Love joins you. Boy, you die to self. Girl, you swell with new life. Air and Fire. Water and Earth. When you take hands you fly, you swim, you burn together."

The Boy asks. "Does the king approve? Are we of like rank? You teach us many things Father, but you never tell us how we come to be here."

"When you dream, you know these things. It is enough."

"Tell me," the Girl insists. "Who is my mother?"

"I know not. But your father is a great king called The Golden One. And you are the son of the queen called Flower of Gold. At your births, ten and eight full seasons past they lived apart and loved apart. Now the Great Love ties them like the ends of a cotton headband. They govern as *caciques* in *Aití*. Go now. Build your nest."

"How, Father?"

"Watch the hummingbirds."

"I see that before, many times."

"I, too, Father. Is it not the same?"

"You are not the same so it is not the same. Nothing stays. Now is all there is."

His voice fades like the song of the morning bird and like a cluster of stars, swallowed in mist, he is gone.

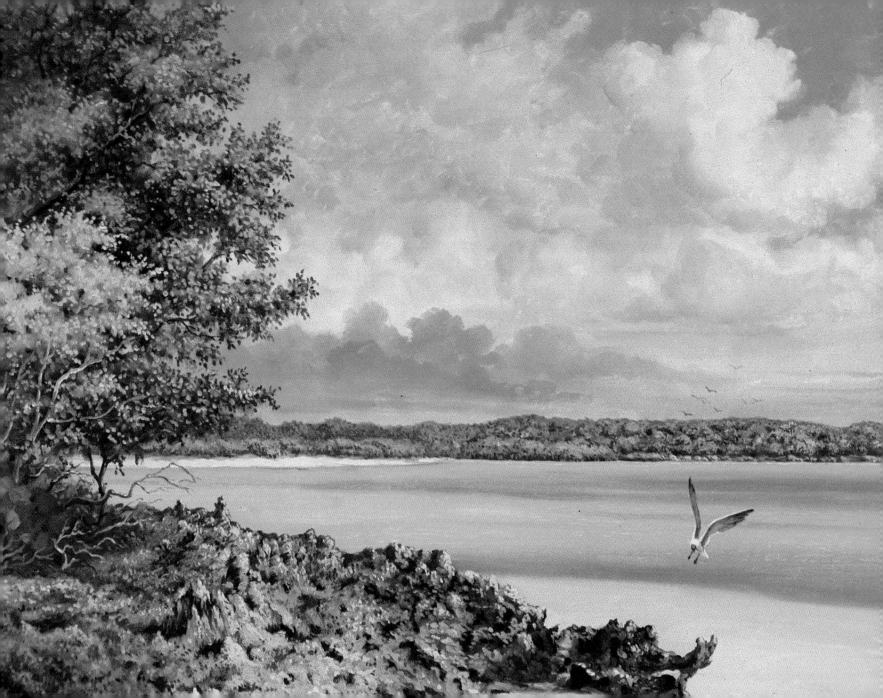

They run. They race along the beach. Sometimes he flies ahead. Sometimes she. Laughing with the wind. Chasing their shadows into the water. The tightness in his chest loosens. The heaviness in her belly lightens. Their arms, like wings, cut the breeze. Jumping over tree roots, they startle shore birds, who sweep their numbers out to sea and swing back behind the couple to protect their nests. Still running, they turn back to watch. Near their feet a tern flops and rolls, playing at death to distract them from her nest nearby. Bursting with laughter, she breaks down the beach. He springs through the sand after her. Beadmakers look up from their work. Their faces become a blur of smiles. They run long and soft, cushioned by the sand, exhilarated by their bodies' energy, brightened by their own radiant joy. White sand meets gray rock. They turn inland and drop onto a grassy knoll by a still pond. The silvery leaves of the buttonwood branches embrace them.

The male hummingbird swoops low over the pond. Again and again, climbing ever higher, diving ever lower until the female joins him. Their tails touch — his forked like a split branch, hers rounded like a river rock.

Soft whirring. Streaks of green and white and violet flicker from flower to flower, dart at specks.

Hovering over her hand in lightning stillness, a bird's tongue extends to taste her fingertips. Finding no nectar in her dye-red fingers, it beats away.

All about them now, sparks of green irradiate the woody pond.

"If we beat at their speed we can fly to the stars."

Reaching to touch his lips, "First learn to build our nest here."

The birds bring bits of cotton to the branch, both male and female knit their nest.

<center>Woven tightly.</center>

<center>Thickly feathered.</center>

<center>Rounded perfectly.</center>

The birds bring bits of leaves to cushion the hard sticky floor.

"I make mats of palm for our floor too," she motions. "And weave a tight *hamaca* which you hang from strong posts."

The energy of the busy wood charges the air. A yellow butterfly lights on a water flower in the pond and flutters slowly.

Mornings.

Hutía caught in the nights' hunt is cut up and readied for the evening stews. Women split the meat with knives of *manatí* bone. In every village around the island, in every season, women slice *hutía* with *manatí* bone for the pepper pot and thank the small night creatures for their sacrifice. All the mornings. Bury their bones in the earth. Hunt them with dog and dart at night. All the nights.

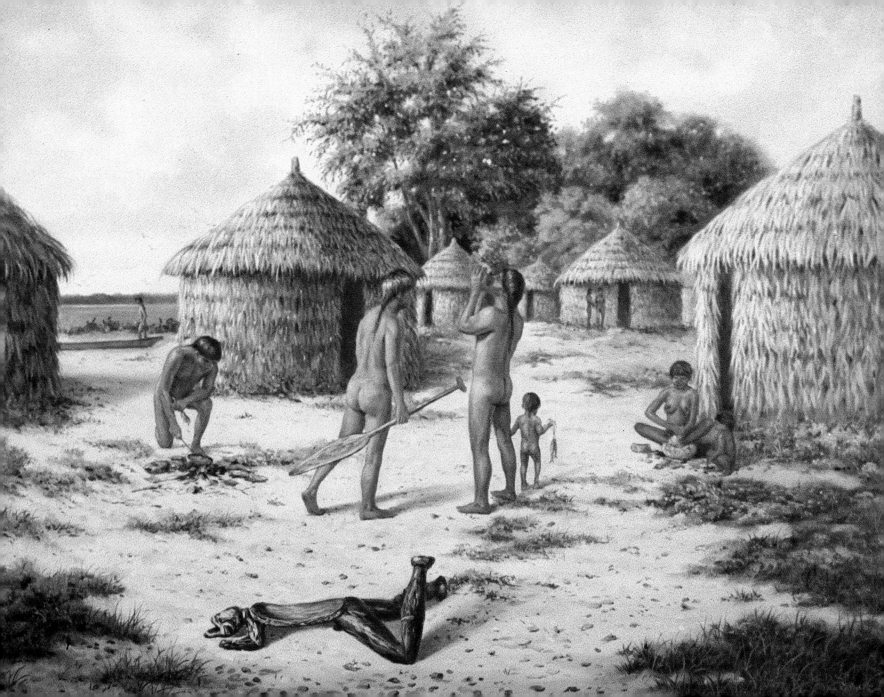

Morning songs.

Gather salt from the shallow ponds. Gather spices for cooking, herbs for healing, cotton for nets. Gather fruit. *Guayaba. Papaya. Banana.* On the *barbacoa* dry the *maíz*, store our food. *Aje.* Dig up the *yuca*, roots of the *yucaiba.* Sing. Scrape. Grate. Squeeze out the poison. Sing. Bake our bread. Sing. Make our wine.

Gather the wood from sick and dead standing trees. Wood to make our fires dance. Posts to make our houses strong. Boards to cut for oars. *Mahogani*, the red-brown wood. Logs to hew our *canoas* to carry us over the ocean to trade. Wood for the bow and arrow shaft, throwing sticks and harpoon to fly and strike on our hunts. Wood to make music. The music of reeds stirring in the wind, a soft, high bird song, wind whirling through ocean caverns, the whoosh of bats leaving the cave at dusk, the beat of the rumbling waves, light scented breezes ruffling the trees. Hunt with us. Dance with us. Sing with us.

Father takes up a conch, breaks off the top, cuts a large hole in its back, puts the hollow tip to his lips and blows two notes in summons. On the bluff he stands. The ocean pounds the rocks below.

The Boy and Girl come to him. They kneel and touch one hand on the ground, then to their heads in greeting.

"We are ready for you to light the new fire."

Wood brought by people from every part of the island is carefully laid. Once lit, villagers come and take these embers to light their home fires. Fire tenders keep these embers hot for many days, many nights.

"Girl, go and ask that tree which straight branch it honors itself to give to make our whirling stick. Boy, find a strong flat board fit to receive the shaft she makes."

Father kneels beneath a thatch palm, broken conch shells spread before him. The Boy returns. Then the Girl. They kneel to face him.

Father curls his left hand inside a fragment of shell and smooths his thumbs over its battered ends. With both hands he raises it to the sun. "You feed our bodies with your flesh. Your shell touches every part of our lives. The Great Worker sees what you do all day, every day. Your cups hold our water. Your spoons hold our food. Your swallowing sticks purify us. You weigh down nets, dig sand, chisel wood, gouge limestone, chip coral. You drill and scrape and notch and grind. You are our cooks, our potters, our fishers, our farmers, our artists, our priests."

Father takes a pinch of crushed shell used to temper clay to make vessels and griddles. He puts a flake on his tongue. The Boy and Girl do the same. "We are one."

The Girl takes up a jagged tool, notched twice the size of the one she uses to smooth an arrow shaft. She scrapes with even strokes up and down the long fire stick. The Boy takes a gouge and first tests the hardness of the board. Pushing, gently, he loosens the wood and readies a circle to receive the action of the whirling stick.

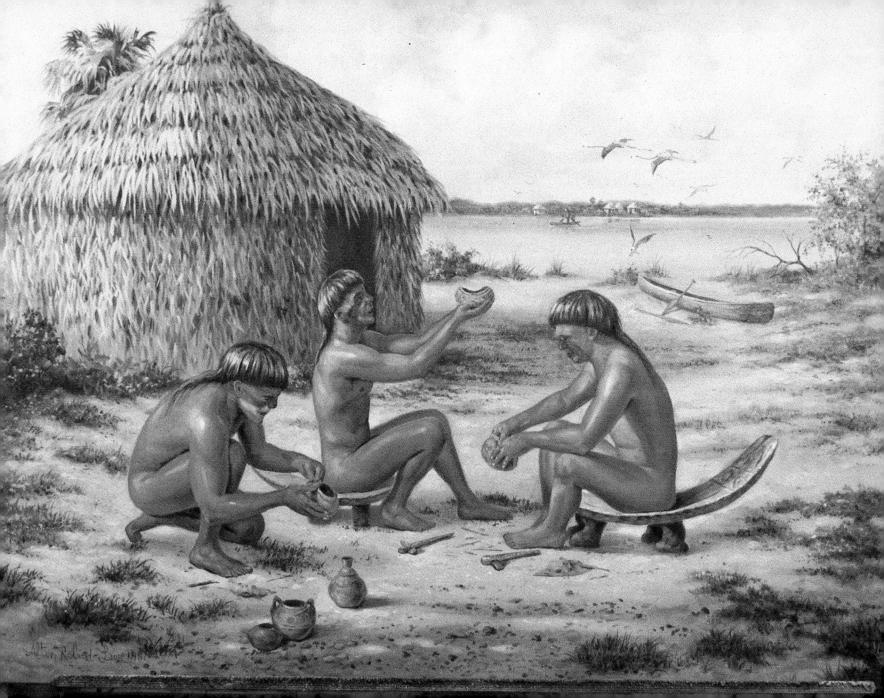

While they work the wood into flesh, Father chooses a pointed shard. On a thick round shell fragment he scratches the likeness of the Mother of the Moving Waters. Eyes wide. Breastless. Fists thrust under her chin, elbows pressed to her sides, legs drawn up. Birthing.

Scrape
Gouge
Scratch
Smooth
Rub
Polish

The Boy kneels and sets his foot on one end of the flat board. The Girl puts the fire stick in the prepared place. Spinning the stick between her palms, she works her hands firmly down the stick. When she reaches the bottom, the Boy begins his motion, pressing and moving his hands back and forth down the spinning stick. When he reaches the base, her hands are at the top again. Whirring in a steady rhythm, they kindle.

Tipping the embers into shavings of dry bark and cotton, they softly blow the tinder into flames and lift their arms to the sun.

"Does it anger the Great Fire in the Sky when we take a piece of it?" she asks. "The people think so and shake with cold in the night rather than make a fire."

"The life within you takes its food from you. Does that anger you?"

"No, I. . . ."

"What is your deepest fear?"

"I do not know, Father."

"Find it."

She looks at the Boy whose eyes follow a snail carrying its tiny conical-shaped house over the pitted rock.

"He cannot help you. He has his own deepest fear." Father listens and watches the changes in her face. "This is the morning. Your body is sleek. Its glow shines into every eye. Do you fear that in the afternoon when you grow big like the earth that no one can see past your outside self to the inside Self that kindles that light?"

The Boy looks up. The golden flecks in her brown eyes warm him and he falls within their rings.

"You take his hand."

"But I do not know why."

"Sensing is knowing. Knowing is sensing. Can you feel him inside you now? He is there. Swimming with your child. You arc soft this morning like the water flower. Other mornings, most mornings, you are the fleshy plant that shoots its darts at everyone who comes too close. See this Boy's body, pierced all over with your yellow spines. Do you wish me to take you to the interior where you can be alone to cry for yourself?"

"How can I be alone? He is inside me and a new life is inside me."

Father snaps his fingers. "He is back now. And you can rid yourself of this child. Any of our women can tell you how. Then you can be alone."

"I am ugly like the prickling plant."

"He tastes and finds you radiant. Your child tastes and finds you healthful. Taste of your own red fruit." He fingers a cord of cotton dotted by small, round, flat pieces of shell. From it hangs the lumpish figure of the All Mother. "I have made something for you. If you find her ugly squatting there, do not take her up."

Father takes from his neck the cone-shaped image of the

All Father, The Provider, Giver of *Yuca*, Giver of Life, made from one of the humps encircling a conch shell.

The Boy extends both hands to receive it.

Father ties to the middle of his own forehead a conch figure of The Dog, wide eyed, whose male part reaches his chest, whose fists press under his chin, whose elbows grasp his sides. "We draw our strength from these. This is for you, young master, to give bread to our peoples' bodies and spirits. For me, a guide for my spirit once I leave this body in death. And you, the courage to give birth alone."

The Boy feels the heat of his loins penetrate the cold dark water and he is alone.

Father flies with the Spirit of Darkness and he is alone.

Hearing the spirit song of the All Mother in the trees, she feels the pull of life and she is alone.

The chunk of shell sweats in her small fist. She ties it around her neck.

"Like the arms of the love vine, our lives entangle."

19 March 1492 Castile

The priest sings the first words of the mass. We chant the antiphon.

Introibo ad altare Dei. I go unto the altar of God.

Waiting. Waiting. Waiting. My Queen, I fear you have deserted me. On my knees before the statue of Our Most Blessed Virgin I pray your gracious Majesties will give your royal permission for my expedition. I require only three or four caravels equipped for exploration and ask only a portion of revenues from the trade in the Indies for myself. Since this is the holy season of Lent, I shall fast and pray until I hear from you. I shall fast until Easter, even to the Feast of Christ's Ascension if I must.

The mass is ending. The priest is chanting the last gospel of St. John.

In principio erat Verbum, et Verbum erat apud Deum, et Deus erat Verbum. Hoc erat in principio apud Deum. Omnia per ipsum facta sunt: et sine ipso factum est nihil, quod factum est: in ipso vita erat, et vita erat lux hominum: et lux in tenebris lucet, et tenebrae eam non comprehenderunt.

In the beginning was the Word, and the Word was with God, and the Word was God. The same was in the beginning with God. All things were made by Him, and without Him was made nothing that was made: in Him was life, and the life was the light of men, and the light shineth in the darkness, and the darkness did not comprehend it.

Cristóbal Colón

People gather on the pink-white beach facing east to sing the morning songs, to dance the morning dances, to chant the morning chants, to kiss the air.

A flurry of plumed bodies soar, swoop. Sideways and backwards sweeps of green, white, reddish brown and violet. Children with baby feathers dance with hungry mouths. They chant.

h'm MM h'm MM h'm MM h'm MM

The First Bird hovers. Sips the flowers in the headdress of the First Father. Sips the flowers growing from His sacred fingers.

h'm MM h'm MM h'm MM h'm MM

Out of the Darkness He grew. His Thoughts His Sun. He lights the world by His Own Inner Self.
All lips meet the air and separate.

pha PHA pha PHA pha PHA pha PHA

He is the First Wind.

pha PHA pha PHA pha PHA pha PHA

Butterfly sing.
Sing to the scattered vapors. Bring them whirling into order. Carry this, the First Command of the Creator.

Drum beat. Pipe sound.
· Heart pound. Earth pulse.
Shake the shaker. Live the story.

Sing the song of the Dreamer Who Makes. The crawfish who makes the earth. Dance the dance of clawing sand, of scooping mud. From the ocean's floor build an island. Make a world.

Earth breathe. Sing. Dance.
Dream the First Dream.
Sing in the Sun, the Moon.

Dance the first dance of the sun and moon. Out of the first cave the sun and moon fly into the sky.
Sing the song of the first people who live in a paradise inside the hollow earth. No sickness. No pain. No death. No sun. One man comes out into the darkness and returning too late is carried off by the sun. Hide from the sun. Close the cave. Outside the man is turned to stone. By the door of the cave sits a stone. One stone. More people come out to go fishing. They are taken by the sun and turned to trees. Another man goes out to find the soap plant to wash himself. The sun catches him and changes him into the bird who sings the sorrowful morning song. Dance the dance of the rocks and trees. Sing the songs of the birds and creatures of the earth.

Chant the chant.
Go with the sun. Return with the sun.
Nothing ever dies.
Go with the sun. Return with the sun.

Drum beat. Heart beat.
ta TA ta TA ta TA ta TA
Pipes sound. Shells clink.
shake SHAKE shake SHAKE shake SHAKE

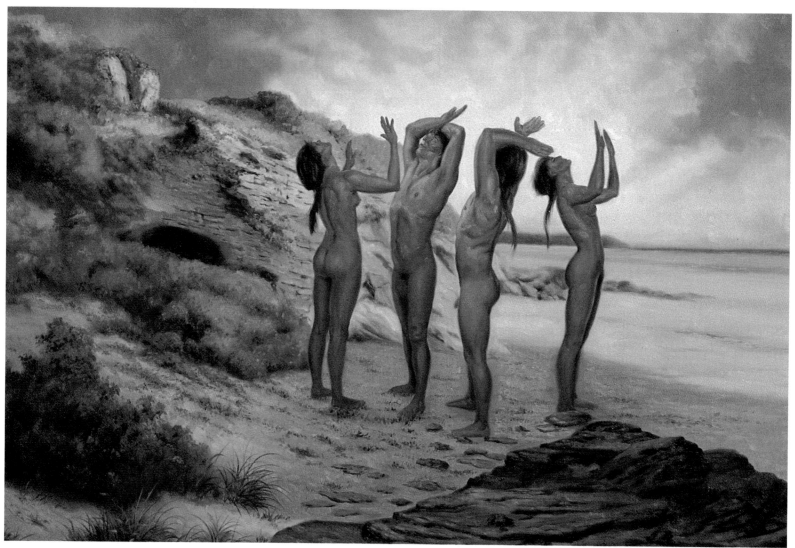

Dance the first dance . . .

Sing the song of the separation of men and women. The man does not return with the soap plant. He is the morning bird. An angry man says, "I will leave this cave and search for other lands. Women, leave your husbands and take gemstones. Leave your children and take only plants." He leaves all the children in one place. Leaves them crying by the brook.

ma MA ma MA ma MA ma MA

This is how children become frogs and cry for the breast.

toa TOA toa TOA toa TOA

He carries off the women to Matinino and leaves them there alone. The island of women. Alone.

The men left behind bathing in the water want women. They search for women in the rain. Eel-like creatures fall from the trees. Swift and slippery they speed away. The men catch only four and wonder what creatures these might be with no parts of male or female. Eels with arms and legs. They tie up their arms and legs and bind a woodpecker to them. The bird thinks they are logs and bores a hole. The wheel of life begins.

Chant the chant.
The Creator is One, becomes two
Makes three and four and five and
We begin.

Sing the songs through all the mornings.
Sing all the morning songs.
Again and again. Over and over.

Sing the song of the sea. A cacique buries the bones of his son within a great gourd and fastens it to a beam in his house. One day he comes and takes it down. Opening it, whales and other monsters of the deep come forth. He tells his people not to come near this gourd for the sea is contained in it. Four brothers, whose mother died at their birth, come to the gourd to get fishes. The great man returns. In their haste to hang up the gourd it drops and breaks. The sea rushes forth over the plains and valleys leaving the mountain tops. Our islands.

Dance the dance of the sea.
Dance all the morning long.
Chant the chant.

Sing the song of the great cacique, our first chief who sees our sickness and pain and looks for a way to calm the Unseen Spirit and ease our suffering. Our first leader walks by the sea. The Spirit of the Waters rises from the waves. Talks to him. Teaches him. She gives him a gourd, a holy calabash filled with four white pebbles. Shake the gourd. Dance the dance of the Unseen Spirit. All the mornings, he chants the chant. And after a life of wisdom and goodness he does not die. He goes up.

Chant the chant. Dance the dance.
Do not die. Go up. Go up. Up.
Do not die. Go up. Up. Go up.
Do not die.
GO UP.

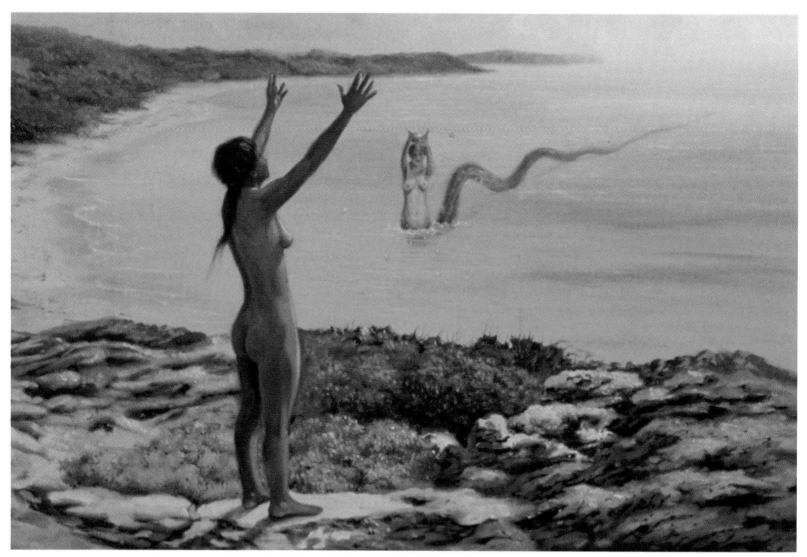

The Spirit of the Waters rises...

Full Sun

The arrows of the sun meet the arrows of the earth.

The Boy falls to his knees. He is alone. After the dancing, after the singing, after the stories, the others go off to the midday meal. He is fasting. Alone.

Half-buried, a chunk of dead coral glints white in the sand. Across the flat rocks in the sea he finds another piece of coral, one rough enough to use as a grater. As he begins to work the coral, he can see the bird inside. He can feel the curves of its rounded body heavy in his hands. Its beak rakes, ruffling its feathers. Its tail points to the sky.

She comes to the beach to fling fish bones into the sea. Back to the beginning. Our beginning. Out of death comes life. Emerge.

Standing knee-deep in the emerald water, she watches parrotfish swim in and out of her legs. Her smile tells him the parrotfish are swimming around her. In the crystal ocean he sees their blues and greens and reds dart after the bits of fish falling from her fingers. Finding a thin, flat piece of limestone, he chops and chips the likeness of a parrotfish — mouth open, eyes ringed wide. He takes the coral bird and the stone fish to her. She lifts bird and fish and her laughing face into the sun.

He kneels, rests his face against her rounded belly and listens. He listens to the beat of life. Warm and safe with the world in his arms, he watches bubbles on the water's surface reflect as stars on the sand beneath. Dancing stars. A perfect world. Does the unborn one feel the sun, smell the air, hear the bird, taste the fish, dance with the stars? He wonders. Yes. Woman as mother is the world — all the lands and seas, sun and moon and stars. The unborn one senses this. He feels it dancing now. Life is all there is.

"Are these stars I see in this coral bird?" she asks.

"Yes."

She draws his face to hers. His eyes are as dark as *mahogani*. She thinks. When I have hurt him in some way, he does not look at me. He walks by with his eyes to the ground. I feel empty then. When he is angry his eyes turn black. In his anger he shouts at me, "You have golden stars in your eyes." The words sting like the bite of the sand fly, yet I laugh. This makes him angrier and he screams, "Your hair is shining." I laugh until he smiles. She kisses his smile.

18 April 1492 Castile

In preparation for Holy Mass my voice startled the priest as I sang out the *Vidi Aquam* for truly this day I "saw water flowing." Our agreement, yet to be confirmed, was signed. I thank Your Catholic Majesties for the promise of caravels, titles, and tithes. Don Cristóbal Colón thanks you. As Admiral of the Ocean Sea I thank you for my ships. As Viceroy and Governor of all the lands I discover, I thank you for the tenth of all the gold, silver, pearls, gems and spices found or acquired by trade in said lands. Above all I am grateful for your blessing on my voyage. The hard work

begins. I pray God give me the strength to attend to the outfitting of my ships and the courage to win souls for heaven.

<div align="center">Cristóbal Colón</div>

<div align="center"></div>

The day grows full. Father, standing on the highest hill, watches, loves his people, blesses their tending. All around the island, they farm in black land and red land and white land. Grow tobacco and arrowroot. Plant the shoots of the *yocaiba* in the red land. Sift the grated *yuca* to make *casabe*, the bread of life. Draw up a hill around the slanted plants.

Heap the earth around the shoots.

In the white land plant the *maíz*. Push in the fire hard stick. Make a hole. Drop in the seeds. Sing the song of the field. Tie the hair with strips of *iguana* skin. Strips cut with *iguana* face bone. Plant the *maíz* in the new moon. From an *iguana* skin sack take seed kernals, the gift of the Great Spirit. Brought from Paradise, the Motherland.

To bring rain, carry two ropes across the round pond in the center of the island. Father looks down. Where the ropes cross, toss in gems and gold and sweet smelling herbs. The Girl drops a blue stone into the pond.

To harvest, gather crops into baskets of silver thatch. Cover them with sweet smelling white flowers and all the flowers that feed on the air. Sing the first fruits. Celebrate the harvest. All the harvests.

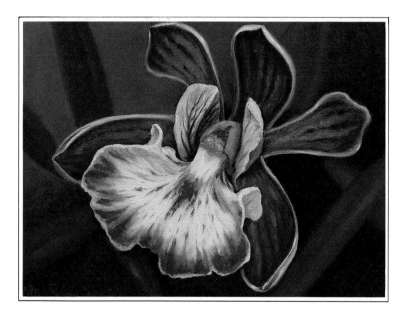

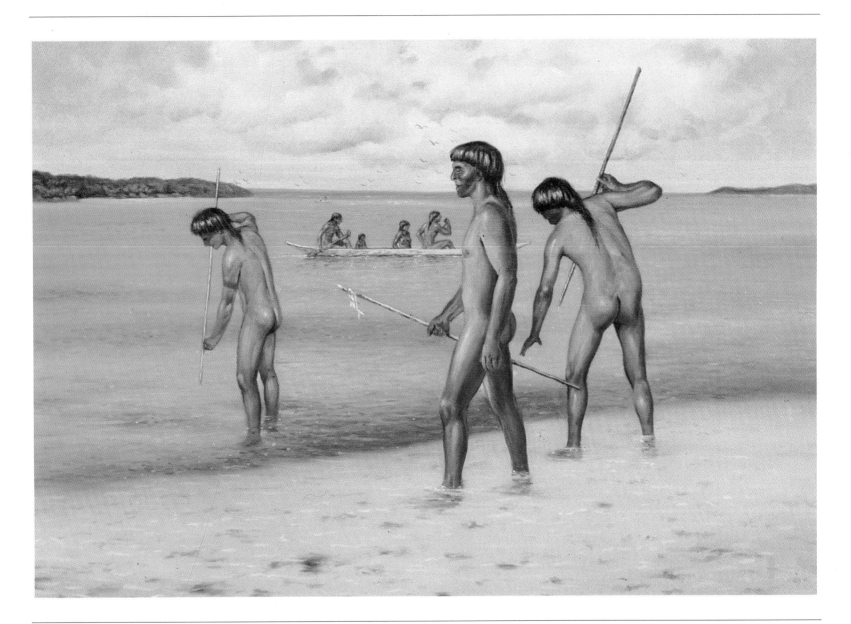

Fishers make nets and basket traps. Watch the spider weave its web and make a net. Take boats out to the reef, set lines and traps for grouper and snapper, grunt and shark. Send the fish to find the turtle, ride the sea turtle, draw it in. In the lagoon crush the leaves and bark of the dogwood. Near the mangroves drag the sack of crushed dogwood. Fish pop to the surface. Toss them in the pepper pot. In the turtle beds place nets. Dig for clams. Catch the crab. In the shallows, throw lines and hooks, fling nets, strike with spears.

At the mouth of the bird lagoon, the Boy stands in the flats. He stands so still his shadow disappears. He waits. A streak of red. He strikes deep with a three-pronged spear. She is a fisher too. He scrapes the scales off his fish with a shell decorated with the sun's rays. She can hit a parrotfish with an arrow.

He hears the squeal of parrots and knows that in the bush young boys are snaring them. He remembers. I catch the first one who answers my call. Its cry brings more birds. It is easy then for a few boys to loop many parrots. We sit in the tree and one by one the birds drop to the ground. The earth beneath us is all green and spattered blue and bright red.

The bird struggles in my hands. My heart hammers my chest. Let me go. The bird speaks to me to set it free. Free in flight or free in death. I am its terror. I cannot soothe it or let it go. In times past I lie in the bend of the tree of life and parrots come to me and talk to me and let me stroke their red throats. That is why I am chosen to catch the first parrot. No more. All the parrots on all these islands know me now. Know how I lie. Bird, you are sacred. Bird, I need your feathers to make a mantle. Bird, you will dance. Dance. Dance. Dance. I twist its neck and scream. All the islands hear my screams. The bird is silent. I lie back along the branch and rest the parrot on my heaving chest until I am

calm. We die to live again. I take all your feathers for my mantle and we dance. I open you and use you for the paste to hold your feathers to the cloth of my mantle and we dance. I take your bones to a high cliff and hurl them into the sky and you fly again.

He looks up from scaling his fish. Several canoes enter the water. Many men and boys paddle to the high cay and to the low cay to hunt the *iguana* with dog and stick. He wants to join them, but she is waiting in his canoe.

The sun is full. She ties a band of cool cotton across his forehead.

"Trading boats approach the north end of the island. We must greet them. Father wishes it."

He sees the water vessel resting on a strut. The bird sitting on two gourds. Its water revived him one morning as he lay on the white-white sand in the early sun.

She tells him what Father said to her. "This sacred vessel came from a great land to the north. It must go back to the north. Now is the time. And this too." She places in his hand a figure of white stone not much bigger than his thumb. "This *cemí* must go to the north where the spirits go."

He lets his finger trace the features of the tiny figure's double ringed eyes, large flat earlobes, belly, absent a button, and the feet — the feet turned backwards.

As they paddle out of the inlet, he can see the people on the high cay. They look like small brown wood doves moving in a line across the island. Very soon now the hunters force out the *iguana* and batter it with their sticks. Dance away from its tail that can slice a man's belly. Skin it. Cut up the meat. Put it in a pepper pot. Season with *ají*. Mash up the rest of it. The *iguana* is tasteful and gives strength. The *iguana* skin keeps babies warm in the seasons of cold. The *iguana* has three eyes.

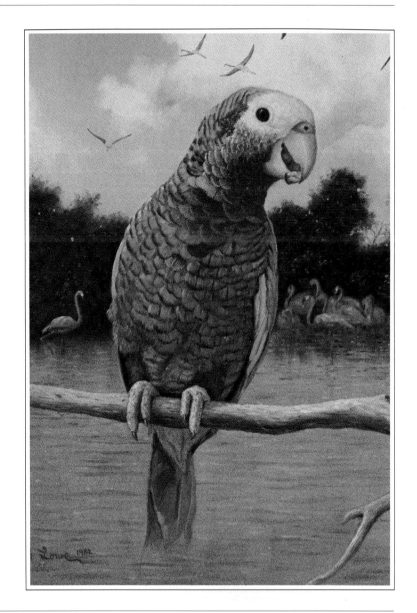

They round a point of sand and paddle up the western coast of their island, *Guanahaní*. The third eye of the *iguana*, what does it see? What does it know?

Gliding through a narrow cut near a green cay, they push across the harbor to the shore where many large canoes are pulled up. On a point of land, cut in two by the action of the sea, Father looks down on them.

Traders come to *Guanahaní* from great lands and islands north and south and west. From near and far they bring the green stone axe, salt and tobacco, plants for skin dye, spices and herbs, the rubber ball for our games. For each our people give many parrots and darts and balls of cotton, all they have. Once for three pierced seeds of the conch the Girl traded many things.

Canoas of all sizes carry gourds of all shapes, leaves and seeds of the plants used in the *cohoba* ceremony. *Cemís*, *coco*, pearl beads from *Cubagua*, a thin, black stone sharper than any bone knife and a fish hook made of gold.

A trader from *Abaco* has a gemstone, bright green like the sea. The Girl hands him the bird vessel. For some beans and leaves used in the *cohoba*, the Boy hands him the white spirit

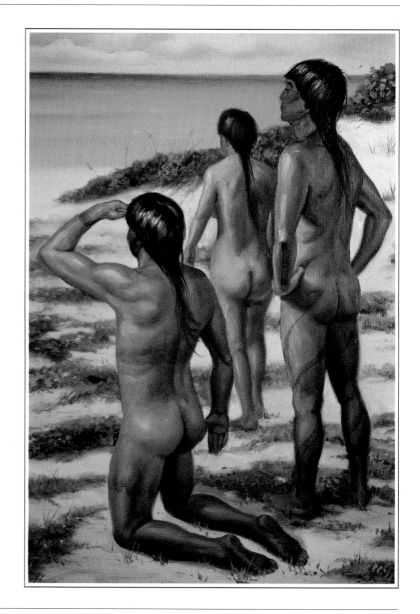

cemí. There are no words. The man gets in his canoe and paddles to his island in the north alone. Hurry. The sea is changing. A big force is coming. Hurry away from *Guana-hani,* our island. Take a calabash of water and a portion of the bread of life. Ride swiftly over the waves to the north, to *Abaco,* your island.

22 July 1492 Palos

It has been eight weeks since I arrived in Palos and we are almost ready for the adventure to begin. Our crew numbers ninety men. The two caravels, the *Pinta* and the *Niña* and the merchant ship *Santa María* have been fitted out for explora-tion. We have readied all our charts. Rations are now being laid in: wine, a good biscuit, oil, vinegar, salt beef and fish, cheese, lentils, chickpeas, honey, rice, almonds, raisins. . . .

Cristóbal Colón

On the point of land cut by the sea, they lie in the swirls of smooth limestone. The ocean rages against its bounds and rushes into the caverns beneath. They feel the earth shake and hear the music the sea makes piping in the hollow chambers. The wind riffs in the trees. Light dances through the facets of the bright green stone. They listen to the music of the island.

The sky is changing. The sea is changing. We are changing. Everything changes. Nothing stays.

They pull their canoe high on the beach and walk a trail to the inland lake. High on a ridge they look back to the north over the bay and rocky point where the music stays.

Down the path at the water's edge her canoe waits. Waiting with his calabashes and lines for hunting ducks, her bow and quiver of arrows for shooting the large birds with the pink and white feathers. Tossing in many calabashes, the Boy enters the water. Through the circles cut in his gourd mask, she can see his eyes move. She laughs and wonders what the ducks think he is and if they think that he, along with the other round gourds, are their own kind. Swimming among them, he snatches a foot and ties a duck to the rope around his waist. Two, three, four, five in all.

The Girl hunts one bird from the many long-legged, snake-necked creatures sifting their dinner from the mud of the black mangroves. One *biáya* smoothing the black tips of its coral wing feathers stands apart from the flock. Here are feathers fit for a *cacique's* headdress. She decides to shoot the bird rather than chase it down. Her arrow is true. Its point kills, but does not tear. No blood to stain the light red feathers. The other birds, startled, move away. She steps carefully, silently, lifts the bird into her arms and retreats.

They do not see me, she says to herself. I walk near them and still they cannot see me. Sometimes when the shadows pattern the west bank, but do not fall on me, I can touch them. I can stroke their feathers. Feathers the color of the flush of dawn. As a child I would run among them, just to see them fly. How wonderful to see them fly. Now I wait all day to see them fly.

One day as a child a dark force fills me up. It moves me to

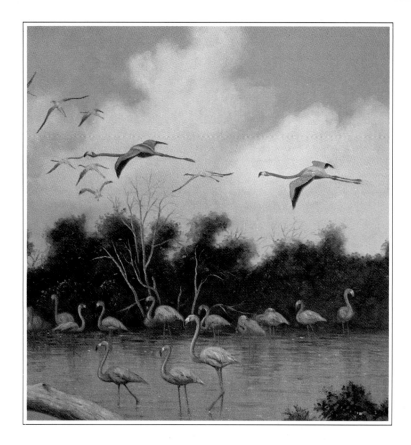

Suddenly all is still. No birds sing. No palms stir. No crabs scratch over dry leaves. It is too quiet. The stillness holds them.

Light flashes in the dark sky.

Paddling smoothly, they wind their way through the arms of the lake, down its narrow chest and stomach into its bowels. The growing wind sends fluffs of brine skittering along beside their canoe.

There is something more. They feel fear. The fear of many? The fear of one? They are not certain. Somewhere on the island, someone is afraid. Where? Near this lake? A boat caught by the waves off to the east? They pull their canoe to shore and run along the path, cross the inlet in another boat and reach the village at the head of the lagoon. They hurry to the bluff and stare into the new fire. Four logs in the limestone depression meet in the center and point in the Four Directions.

"We cannot look in all Pathways. Look into the center with me," he asks of her. "If we can find our center, the calm inside us, we will know which way to go. Point to the log that shows the direction we must go."

She points to the south.

"Yes. But I see no *canoa* out there." Shifting his eyes to the west. "There. The trouble is on the high cay. We need help."

"But everyone is gone into the caves. They fear a big force. We must go alone."

"We must take long, tough *henequén* lines, but I do not know why."

The inlet waters are smooth. The wind fattens and pushes into the white bay where the water heaves. Their flat bottomed canoe glides over the low places and rides the waves neatly.

"Crying. A child is crying. Our child hears it."

hurl many darts among these birds. They rush one way then another before crashing into the mangrove. Father turns my darts into the water. No bird is hurt. Their cries and shouts break the peace of this quiet place. After, Father does not look at me. For days and days he does not look at me. My crime is great. I feel a hurt inside every time I see these birds. The hurt of many darts.

She places her bird in the canoe next to his catch.

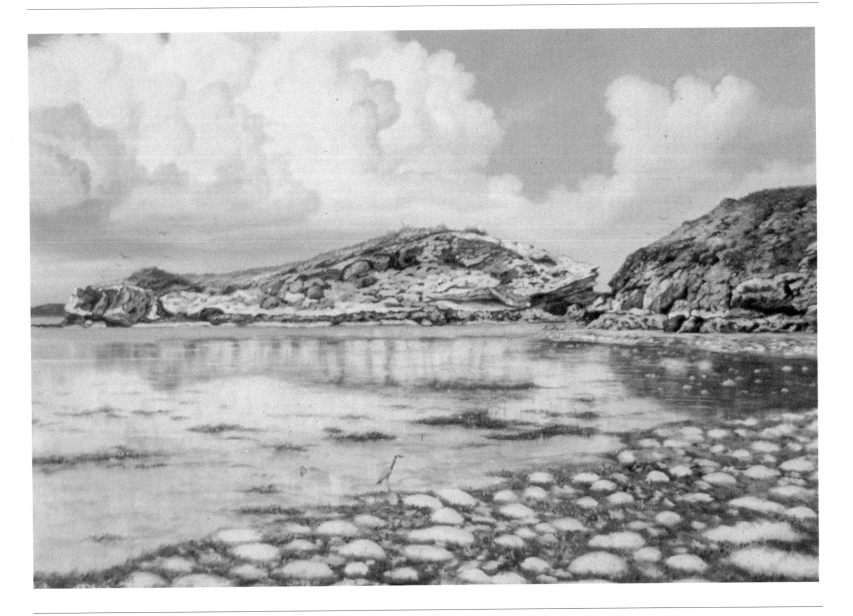

Across the island, over the white cliff they see a child fallen to the rocks below. Fallen with a piece of limestone that broke and fell into the sea. The Child left the *iguana* hunt to look into a sea hawk's nest and wandering to the edge of the cliff, he crawled down on a ledge to see the roots of plants turned to stone. Now he clings to the rocks of another shelf. Down below, the waves rush over sharp coral heads and lash the white stone.

Tying the fibre cords under her arms she steps down the wind hardened limestone. The Child is small and light. From above, he lifts them up and lands them safely in the clusters of the golden, fleshy leaves of the bay cedar that grows along the ground atop the cliff.

Back on the island they climb over the sharp rocks of the southern shore. The rain beats and the wind cuts. Waves blow up through the caverns to swamp them. The Child wants to join his people on the west side of the island. The village of the beadmakers. They have memory of a blur of smiling faces as they run by in the early sun.

The storm swells. Branches fall across the path, the many paths crossing the island. They near the pond of the hummingbirds. The petals of the water flower on which the butterfly sits raise up and are pulled by the wind as if to take flight. The flower sinks. They climb into a cave just beyond the beadmakers' village to wait. The driving rain, the lashing wind, the loud sky is quieted in this place.

The Boy scratches on the side of the cave with a twisted piece of broken conch. Gouges the lines of a face. Outlines a broad forehead and narrows the face down to a pointed chin. Eyes round but taper slightly at the ends. Round mouth open — speaking. He scratches cross hatch lines. The bottom legs of it longer than the top form a nose. The shorter lines above become his brow. And on top of his head a headdress of the

conical-shaped conch knots like the one he wears around his neck.

"A great *cacique*?" asks the Child.

"*Saomete*, King of the *Lucayos*. He lives on an island to the south."

"Will I ever see him?"

"Perhaps one day," the Boy says.

"Yes", the Girl assures him. "Even if the earth should move and break up this cave, he is here."

3 August 1492 Palos

We embark this day. Casks of sweet water from the fountain near the church are being filled. Every man and boy is with me now in the church of St. George. Since no priests will sail with us, it is our last opportunity to confess our sins, receive absolution and the Holy Eucharist.

We repeat the words of the priest.

Confiteor Deo omnipotenti. I confess to almighty
. . . God. . . .

I think back over the many years I dreamed and planned for this moment. I intend to keep a journal of every particular of the voyage of discovery to present to Your Majesties on my return. I remember the day the Moorish King kissed Your Royal Hands and soon the Gran Can of the Orient, the King of Kings, will renounce his idolatries and heresies and accept the Holy Christian Faith.

. . . quia peccavi nimis cogitatione, verbo et opere. . . .

. . . that I have sinned exceedingly in thought, word and action. . . .

Yesterday the Jews were exiled from this city and all your realms and dominions.

mea culpa, mea culpa, mea maxima culpa.

through my fault, through my fault, through my most grievous fault.

Soon I will weigh anchor, leave the harbor of Palos for the river of Saltes. . . .

Indulgentiam, absolutionem et remissionem peccatorum nostrorum tribuat nobis omnipotens et misericors Dominus.

May the almighty and merciful God grant us pardon, absolution and remission of our sins.

. . . sail South by West to the Canary Islands, then due West across the Ocean Sea to the land of the Gran Can, King of Kings.

Amen.

Amen.

Cristóbal Colón

On the white-white beach of the western shore the people gather to sing the songs of the full sun. They form circles along the stretch of sand. Circles of elders. Circles of men. Circles of women. Circles of children. All repeat the phrases of the Boy, a master, their *tequina.*

Song of the Long Long Past

Before the sun. Before death.
Before the ocean falls from the sky.
Before we come from the Land of the West.
The Motherland of man.

Ships like arrows sail on lights.
We talk in thoughts.
Music is language.
The rhythm of breezes and tides.
We move through doors in the earth.

Country of wide plains and soft hills.
A feather mantle of green covers all the land.
Over all the land four rivers flow.

In tall trees birds with bright feathers sing.
Butterfly. Hummingbird.
Spicy herbs. Heaps of bright flowers.
Big-bellied gourds. Tall corn.

Seven great cities. Great houses of stone.
People. White and yellow and brown and black.
Sail all the oceans of the world.
From the eastern ocean to the western ocean.
From the northern to the southern seas.

Monsters roam this land. Small heads on long necks.
Tearing up the green of the earth.
Plants and bush and trees they clamp in strong jaws.
Flying monsters too, swooping up other monsters.

In the night the earth rolls and shakes.
Fires heave and spurt.
The sky breaks.

Some float to nearby shores.
To the east of their flooded land they go.
Others go farther east through tunnel and canal
Across the Great Lake to the Great Land
In the western ocean.

The circles of elders, of women, of men and of children
now repeat the phrases of the Girl, a master, their *tequina*.

Song of the Long Past

The builders have memory.
They build again.
They build another paradise.

Some people eat each other.
Many rather starve and die.
Too many white haired people
Grunting and shaking their spears at us.
Run from them. Fly from them.

Go away from us white-haired people.
Go north away from us.
Far to the north and east.
East of the Great Land in the western ocean.

The Great Land in the western ocean splits.
It sinks and drains our Great Lake into a river.
Mountains rise up in our plains.
We are lost again.

*Father as a sea hawk swoops low and scatters the circles of
dancers and singers. "Never again sing this song. Forget this
song. Lose this song." Father stands on the beach. He takes
the Boy's hand in his right and the Girl's hand in his left. The
people form a straight line and repeat Father's phrases.*

Move forward and back, but always forward.
Walk forward by stepping backward.
Find another paradise among all possible paradises.
Dance the dance. Trace our steps.

From the heart of our new land move north.
Leave the City of Gold by the lake now the Great River.
Never again sing of this city or this lake.

Song of the Tracing Steps

Follow the Great River. Tracing steps.
Life after life. Tracing steps.
At the Black River wind northward.
Live along the Gentle Flowing River.
Life is kind. Life is easy.

Move east out of the mouth
Of the Gentle Flowing River.
Move west. Live from island to island.
West. Home again? No.
Go north now. To *Guanahaní.*

Move forward by stepping backward.
Step backward. Move forward.
Forward. Forward.
Move forward by stepping
Backward.

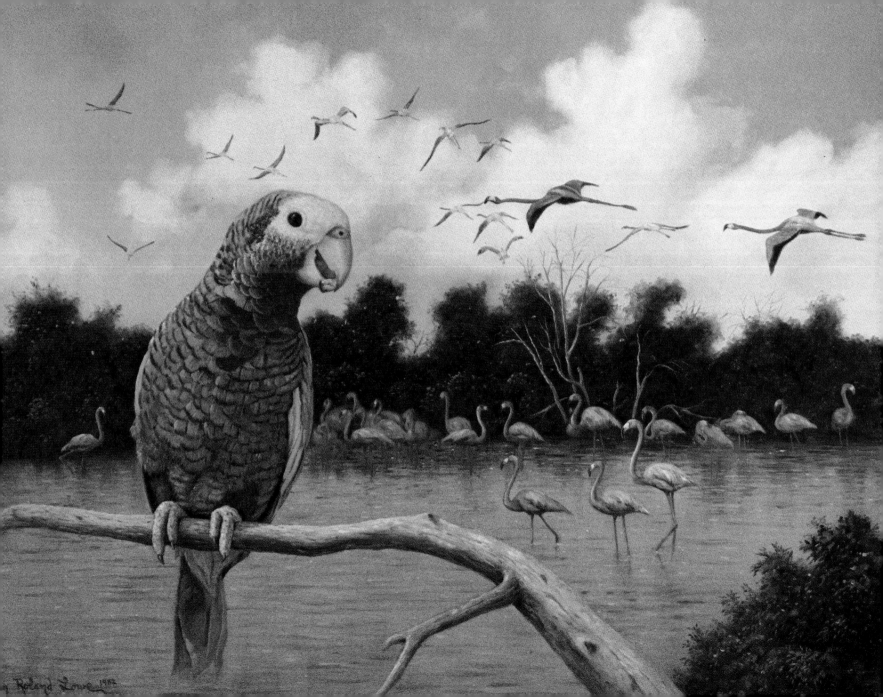

Roland Lowe 1982

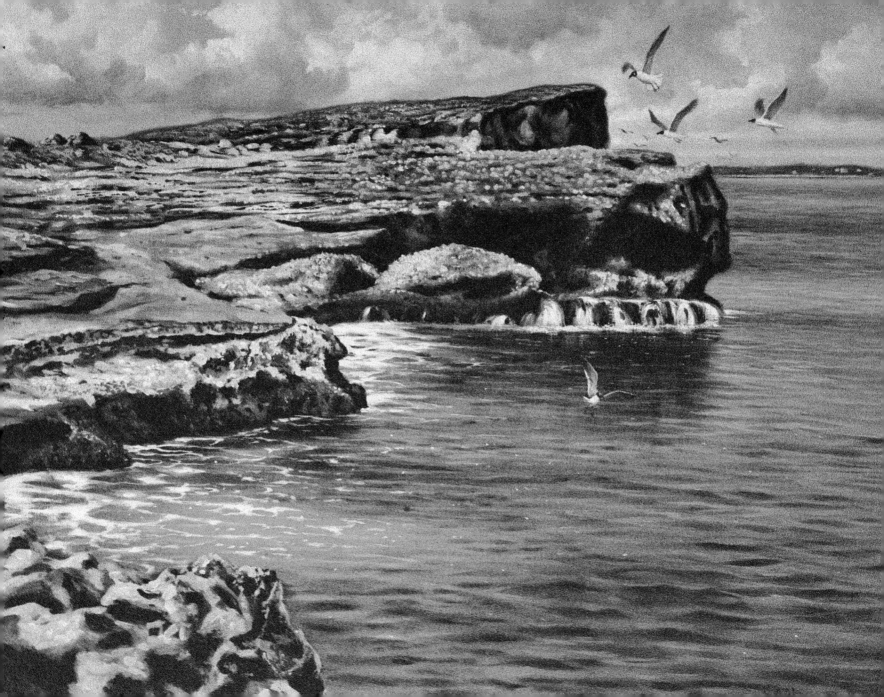

Why backward? In a trance, the Boy drifts out of the line. Where do we go when we move forward by stepping backward? I must know. Where does the song end? What is the next step in the dance?

Father is gone to the point of land at the north to fast and pray for forty suns. I go into a cave. I want to see the time beyond this time. Father knows where I go. He sees what I see. The Girl wants to see the island as the birds see it. She is the fish hawk there in the sky. Father flies where she flies, sees what she sees. When she swoops over him, he does not look up.

The Boy listens to her thoughts.

Why think about time past or time ahead, she says. There is no time but now. Why bury yourself in a cave with our ancestors? Come with me. Look at the reefs protecting our island. High in the sky I can see Father on the point of land cut by the sea and to the point of sand to the south. See the great water in the middle of our island. See how much faster I reach the high cay where we found the Child in trouble. I see him now standing with his fish net in the shallows of the inlet. Red fish like stars in the water all around him. He waves to me and speaks to me. As a child I spoke to the birds. Our child talks to birds. I climb higher and can see all the *Lucayos*. There is our ocean hole. I swoop down over it.

27 August Las Palmas, Grand Canary

We have been in these islands many days now. The *Santa María* is a slow sailer. I must repair the *Pinta's* rudder and rerig the *Niña*.

I am very busy here and have no time to inquire about the situation on these islands. I have heard talk that two conquistadors have been falsely accused and sent home in chains. Some say the Spaniards, through treachery and cruelty, enslaved the Canary Islanders and forced them to convert to the Catholic Faith. I am sure these are but rumors.

Cristóbal Colón

From the beach he watches her fly. She climbs now into a cloud shaped like the spreading wings of a great bird. It is the image of her as she is now. She is safe inside herself.

He runs. The sun burns deep into his back. The sand scorches his feet.

Father speaks. "To look beyond, look within."

"I am afraid. The cave is dark."

He crawls inside to where he can stand but stays on his knees, trembling. Bats veer from him. In the middle of the cave is a small clay-like hill. The Boy sits on top of it. He sets his water bowl in front of him. A bowl of her making — deep, with handles shaped like frogs. He sprinkles a few drops in the Four Directions and sips.

Full suns. Deep in the cave, the Boy does not know how many full suns he waits atop the rocky mound. His stomach twists, his throat aches. Burning pains strike every muscle. His head pounds.

The mind holds many worlds.
Breathe out one world.
Breathe in another.

His body quakes like the leaves of the red trunk tree in a storm. Now it begins. His sinews tear. His torso rises and falls like waves in the ocean. His spirit hurls into the sky. He is gone.

He opens his eyes to fearful sights and sounds. Everywhere there is motion — strange noisy objects with people inside dart by him. Overhead, monstrous birds with shiny gold tail feathers tipped blue and black roar and streak across the sky. Tall structures grow like trees. Where are the trees? Along the too wide paths the bush is black, their leaves are black, their flowers are black. Smells mix to turn his stomach.

A terror wells up in him. White-haired people in bright clothing come toward him. Their garments are dyed and patterned with the stamps women use to decorate their bodies — birds and flowers and turtles and lines and figures that we put on our pottery. These white-haired people are young like me. Why am I afraid? They dance and laugh like I do when I drink too much of the wine made from corn, and stumble like me when I sniff the *cohoba*. The world turns upside down for them too. What is their reason for drinking? Where is their ritual? They beat each other, rape their women and break their sacred vessels. There is no cleansing in their vomit. They have no visions of good spirits. They do not leave this place for a better. They just fall down and sleep in the sand. What do they learn in their trance? Where have they been? Where are they going? They are like the white-haired people of the long past, jumping up and down, grunting and growling and throwing spears at us. Have I come north? I must leave this place.

The Boy is lifted up, pitched and dropped into a muddy field. The earth around him is ripped and scarred. Trees and bushes are broken and pushed aside like some giant beast had clawed, scooped and pulled the vegetation out of the earth then flung it aside. He digs out a small white stone, half buried in the dry earth. It is the spirit *cemí* he gave the *Abaco* trader. He drops it on the ground as he is swept up and carried to another place and dumped into another ruined forest.

He is dizzy but sees tracks, strange tracks unlike any animal he knows. Are they the tracks of the monster who spoiled this land? He follows. High on the hill he sees the water. The same colors of the sea surrounding his island. Can

this be? He climbs a tree. This island is much smaller than his island and he can see other islands close by — trees dwarfed and land barren. Have the beasts come to all the islands?

Down the hill the path widens. It is wider than any path needs to be wide. Trees and bushes and wholesome plants are piled high on either side. Shiny circular objects stuck in the withering branches are the fruit of these dead trees.

Rumbling noises shake the earth. Loud, rattling sounds. He stalks closer and sees the beasts. Golden like the sun. Shiny gold like the beast in the sky in the other place. He is in the midst of their growling and choking and grinding. Long-necked monsters bend and snatch up all the green bush. In every direction they turn and bite the earth. Other shorter-necked monsters with wide mouths fell large trees. Other beasts push the trees aside. Some creatures eat red clay. They chew the earth and spit mouthfuls into hills — clamping, tearing, crushing, vomiting earth and rock. On circling banded feet they crawl. One is close by him now. On its hide is a drawing — two lines within a circle.

It begins.

This picture tells me this is only the beginning. These monsters produce more monsters to rape the earth on all the islands. I cannot breathe. There is no air here. The smoke from these beasts chokes me. I am killed.

On the tail of one beast is a picture of a sleek creature with branching horns leaping into the air. I do not know this animal but I can jump the way it jumps. There is hope in the jump. He leaps into the air and when he wakes he is kneeling on the mound of dripping rock. The vessel is overturned.

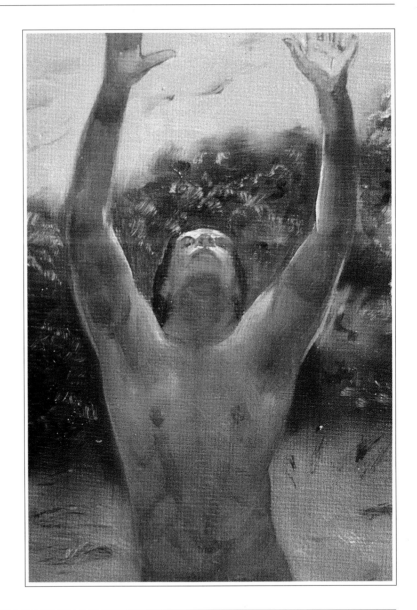

Night Sun

He fumbles for the vessel and raises it to his cracked lips. The last drops of sweet water taste bitter. Slumping on to the rocky mound, he lies prone, arms outstretched, eyes shut against the splinter of light falling on his face. Senses battered. Body knotted. Heart empty.

Leap to a star. Leap like the hooved, horned creature into the sky. The stars are our only hope.

11 September The Ocean Sea

I watch the stars. I tell the time by Polaris and navigate by the North Star. *Cipangu* is on the same latitude as the Canaries. Of the eight winds Japan lies West. The ocean between the Canary Islands and Japan is short, only 750 leagues. If we miss that island we will surely reach mainland China, our primary destination.

This is the third day since we last saw land. The weather at sea is like Andalusia in April, but here there is no song of the nightingale.

Every tierce, vespers and complin I pray to Our Lord and Savior Jesus Christ to spare us from storms and calms.

Cristóbal Colón

The Girl talks to the plants, asks questions of the bushes and the flowers. They respond by telling her their many uses, their many pleasures. She comes to the white bay near the high cay with her basket of soap leaves and fragrant plants to wash.

The Boy uses a swallowing stick and coughs up what appears to be the black juice of the poisonwood tree. He staggers into the water. The stick floats out to the open ocean. His body is covered with the grime of that other world. His nose is filled with its smoke and soot. Lathering the leaves, she rubs his tight shoulders. He feels like the yellow-green matted vine which grows in aimless directions in and out, up and down and around itself.

She is filled with her adventure. Filled with the wonder of their island, shaped like an egg with a body of water inside — lakes and ponds and blue holes. Clothed in forest and mangroves, hills and cays. *Guanahaní* is like the earth, the Great Mother. The lakes and ponds are her blood and she turns herself, first one side then the other, to the sun to warm herself.

"From the sky I saw the small island to the south and west. A great *canoa* is coming." Her fingers work the lather into his hair. Her excitement dims in his silence.

The sun drops.

He tries but cannot find the words to tell his vision. There is no language for it. No music, no song, no dance can tell it. The gulls and terns screaming and fighting over bits of bread is a piece of that world. Parrots squawking to the aid of one of their own is part of it. He tries to tell her about the

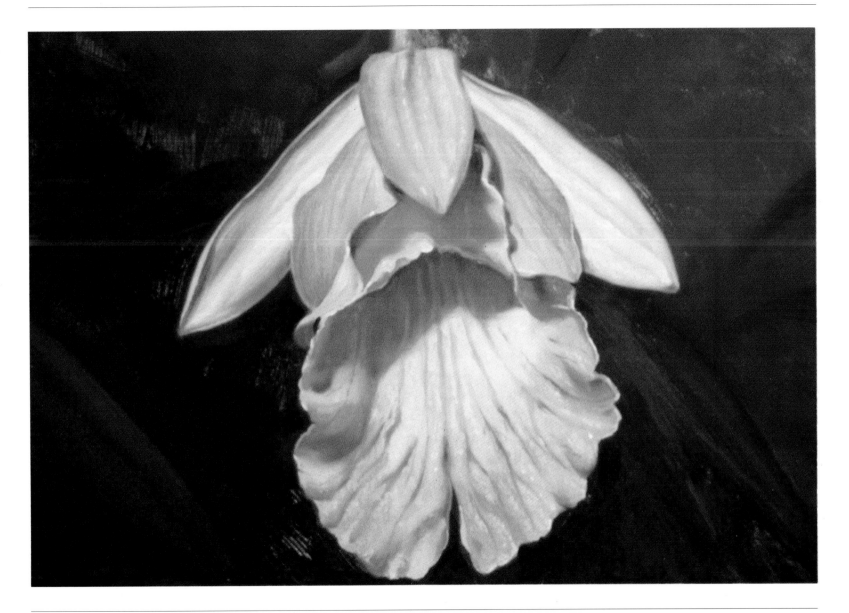

monsters who eat up the land but she cannot picture them.

"I must fight the yellow beasts. They are ten tens my size, still I must find a way to destroy them."

"Where is the wisdom in that?" She crushes the petals of a fragrant flower and smoothes them over his face and neck.

"If we cannot change the time beyond this time, we will choose another."

21 September 1492 The Ocean Sea

We have been in the Sargasso Sea several days now. The ocean is a rust-green meadow. Although the men are fearful of being stuck in the weed, I keep a straight course.

Cristóbal Colón

Saomete's canoes round the sandy point and glide up the western coast. Many flat boats come. Many people come from other Lucayan Islands. From *Biminí*, the island of the healthful spring, to *Inagua*, the island of the pink birds. From *Abaco, Bahama, Habacoa, Guanima, Exuma, Samana, Mayaguana, Caicos*. He could name them all, ten tens of islands in every direction. Yet, no canoe ever comes to *Guanahaní* straight from the east.

Saomete, all golden, steps from his *canoa* and approaches Father. The Boy is on Father's right and the Girl on his left. The three kneel and touch the sand, then their foreheads. The sun falling behind the great chief glints on his headdress, neckpiece, belt and armbands. *Saomete*, radiant, takes in his arms the son of Flower of Gold. Looking into the Boy's face, the *cacique* has memory of *Anacaona*. He can sense her wisdom, feel her tenderness, see her beauty, hear her poetry, sing her songs, dance her dances, taste her nectar.

The two feathers in the chief's headpiece stir in a breeze. Only then does the Boy's gaze leave *Saomete's* eyes. *Saomete*, King of the Lucayos. Is he the *cacique* of the dawn? the Boy wonders. He cannot be. He comes from the south. Who is he? Like a leaf on a stem I am connected to him but do not know why.

The Girl catches his eye and tells the Boy to ask no questions. He smiles and looks at the red-orange circle in the sky. All look. The ocean which rages against its bounds and swallows the rain is waiting now to quench the Great Fire. All along the beach the people stand. A line of people stretch northward and southward. Along the sandy beaches and the rocky shore they watch the sun.

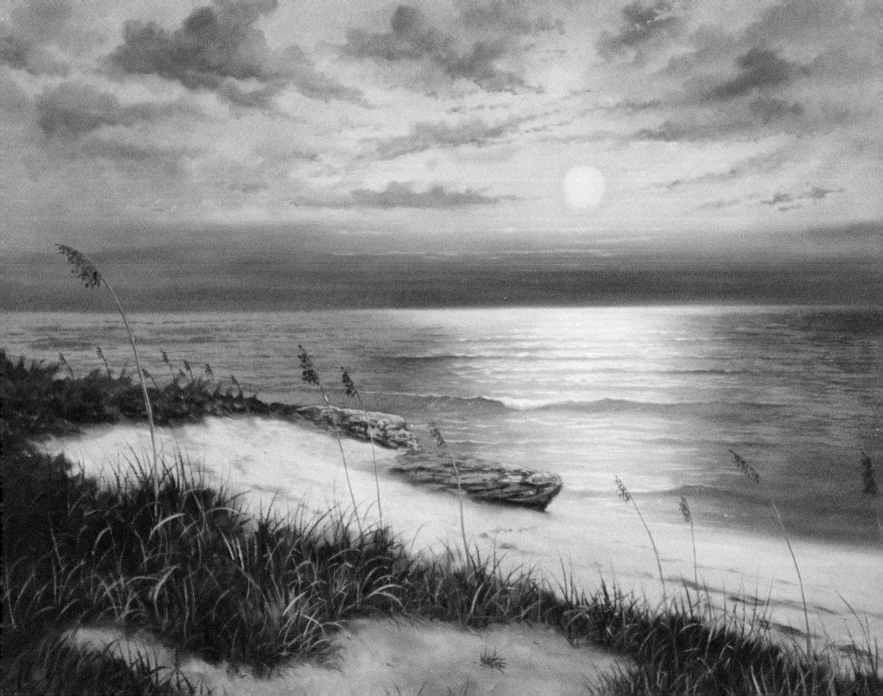

She is frightened. The falling sun always frightens her. She takes the Boy's hand and moves with him and *Saomete* into the line of people on the long stretch of beach in the middle of the island.

Father, knowing that the body is thought, goes with his thought to the village of his birth on the northwest point to stare at the sun. With a splendor all around him, Father chooses to go with the dying sun.

All the people, the old and the very young, sit on their heels, rest their elbows on their knees and face the palms of their hands toward the ocean. They stare straight into the sun and with gaping mouths they call. Summoning croaks, rasps, and screeches from the back of their throats they shout their farewell. The bellowing, hooting, squawking continues until

flashing green
the sun
drops
into the sea.

It is the moon of the first fruits. Inside a house, *Saomete* rests on a short stool on a raised place made from the inner bark of a palm tree. He sits on a *duho* carved in the likeness

of part man, part lizard. On his head he wears a headdress of seven pointed fragments taken from the conch.

"I want to see him," the Child from the beadmakers' village tells the Boy, son of Flower of Gold. "Every full sun I go to the cave to see his face. I want to see the rest of him."

"We must wait here until after the women present the first fruits of the *yuca* harvest, then he will come out."

From all parts of the island the women come. In the house they set their baskets of bread before *Saomete*. The *cacique* uses this house when he visits the village at the head of the inlet on the eastern shore of *Guanahaní*. On the ridge along the beach all the houses glow in the yellow moon. Inside, *hamacas* with sleeping children swing, baskets with the bones of ancestors hang. In the largest house on the highest land *Saomete* sits on his honored place. Women lay their gifts all around him. The Girl is among them. Big with child she kneels behind her basket of *casabe* made from roots planted, nurtured, gathered, squeezed, grated, pounded and baked by her own hands.

Saomete's wives dance the dance of the first fruits. They dance with the outside of their hands turned outward. He watches as the subtle movement of their feet sets their hips to swaying and listens to the tinkling shells on their ankles. But it is the hands that speak to him — smooth, graceful, the backs always facing him, fingers stretching, looping towards him. These hands tell of his generosity, his authority, his vitality. They tell of the many gentle, loving kindnesses he bestows.

Receive, great cacique, these our gifts
The first fruits of our fields, of our wombs
All the fruits.

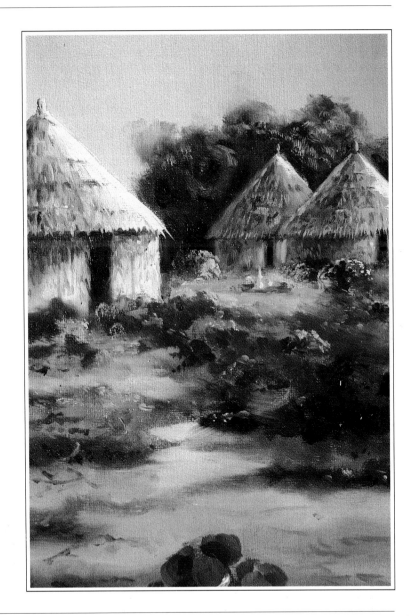

When the dance is ended the women take their baskets of bread outside to a large open place where the people wait. Stout men carry *Saomete* in a hammock chair to the plaza. Here before all the people gathered from the Lucayan Islands, *Saomete* blesses the bread. He breaks it and gives it to the people.

In a loud voice he speaks. "Take to your houses this bread, the gift of the Great Spirit. Keep it for twelve moons to protect you from the big force with the lightning that shatters trees, the wind that tears our roofs and the rains that drown our crops. From these and other dangers protect us."

The people chant the name of the Great Breath, the Creator, The Giver of Life.

> *Huracán Hu racán Hura cán Huracán*
> *Hura cán Hur a cán Huracán Hur*
> *a cán Hura cán Hu racán Hura*
> *cán Hur acán Hur a cán Huracán*

The Boy has memory of his vision and wonders. *All* other dangers?

6 October 1492 The Ocean Sea

Martín Alonso Pinzón thinks I have passed Japan. He urges me to change course to SW by W. I fear I may miss mainland China, the land of the Gran Can, King of Kings.

The men are restless. Almost two weeks ago we mistook the sky for land. I know we have passed the island the Portuguese call Antillia — the seven cities. But I must not miss China where the roofs are made of gold.

<div align="right">Cristóbal Colón</div>

Night.

Men carry the silent dog on their shoulders to hunt the *hutía* with torch and spear. In the night, plant crops by the moon, parts of moons, the twelve moons. At the new moon women plant *maíz*. Fast and feast. Fast to cleanse our bodies. Use the swallowing stick of wood, of shell, rib of *manatí*. Drink the black drink. Sniff and sneeze. Purify our bodies to receive the spirits, see the visions, know the signs. At ceremonies and festivals feast and drink. At times when the moon and sun disappear, feast and drink. At times when the sun rises casting its longest light, feast and drink. At harvest festivals feast and drink. At night, the light of other worlds bursts forth overhead. A wide roadway of stars stretches across the sky, the path of the soul at death. At night. All the nights.

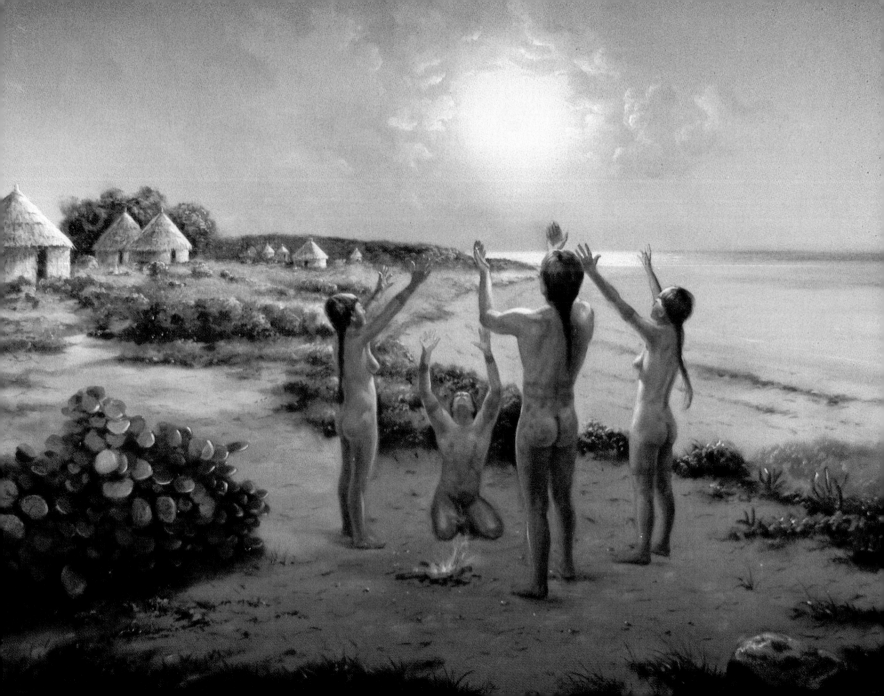

10 October 1492 The Ocean Sea

Three days ago I changed course WSW. Forty petrels flew by our vessels in that direction. A boy hit one bird with a stone.

The moon came full five days ago. At night we hear birds and see them in flocks so large they shadow the moon.

Cristóbal Colón

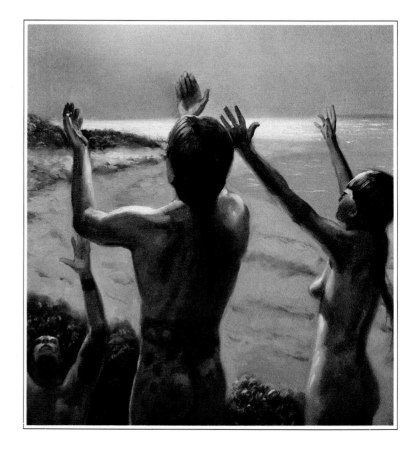

The Girl looks up at the full yellow moon and has memory of other nights. A night before the night the Boy and I are joined he leaves me standing at the north point. He turns his back and walks away from me into the night. He must walk around the island to return to me. To face me on his approach, he must circle the entire island. It is necessary, Father says, for him to walk away and for me to stand here alone, to feel the sorrow and the joy of life and love. For all the days in one day.

Father knows the signs. He tells us it is time to tie ourselves, each to the other. That although the Great Love blesses us, it is necessary to perform the ritual with the people present.

"The ritual is necessary. In the moon when the sea grape leaves turn red you must marry. You cannot love and live apart. You must live as one. You, woman, see the man in you, and you, man, see the woman in you. This is knowledge."

She has memory of only pieces of that night. She and the other women hold baskets of pots at a rocky point of land in the middle of the north end of their island. Baskets of pots covered with flowers — the yellow of the rock flower, the

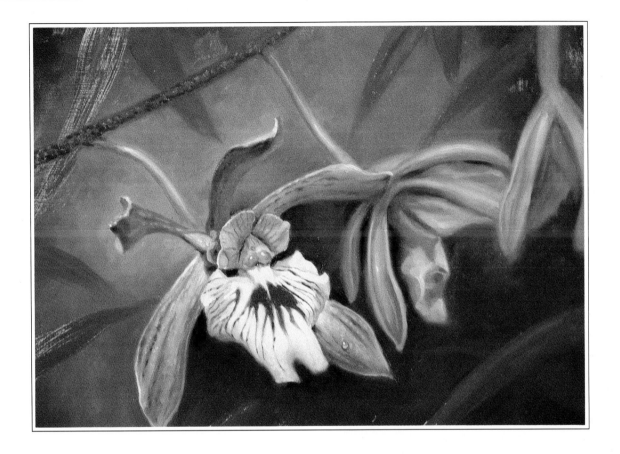

pink of the dogwood, the blue of the tree of life and all the flowers that live on the air. The yellow moon hangs low over the bay of the traders. Before the men come, the women break the pots. By the light of the night sun they break all the pots in all the baskets. Sing the song of breaking pots. Dance the dance.

The moon disappears and the men come. Beat the drums, pipe the pipes, shake the shakers, rattle the gourds. The fire burns bright. Dance the fire round. Keep the fire on our right. Dance round and round.

I stand on a high place with the Boy and Father. Hand in hand we stand, our necks encircled with ropes of scented white flowers. The fire blazes beneath us. The air chills, a thin mist covers the stars, the moon disappears. The people lift

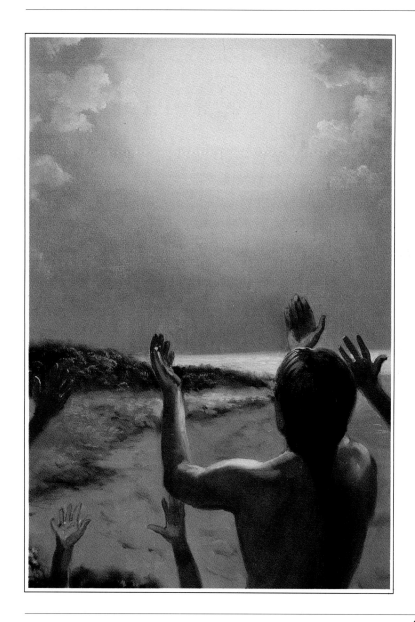

their eyes to heaven in amazement. Lit from the fire below, the shadows of our forms appear above us. Hand in hand we hang in the misty sky.

11 October 1492 The Ocean Sea

Yesterday the crew was mutinous. I told them that we would turn back if we did not find land in two or three days. I promised the men I would not abandon them to an unkind fate and at vespers invoked the Blessed Virgin Mary to protect us.

Since sunrise we have had many signs of land. The *Niña* picked up a green branch loaded with little flowers like our dog roses and the *Pinta* found a small wooden stick which looked as if it had been carved with iron.

Cristóbal Colón

"Where is Father?" She asks the Boy as she prepares his powder for the ceremony of the *cohoba*. "Did you look for him?"

"He is gone to another world. We buried his body in the forest surrounding the dancing circle. He has memory of his vision. It is best."

"For him. What about us? What about the one soon to be born? The child needs him."

"You are sad for your loss. That is why you are angry. Are you afraid to be alone in birth? Did you think maybe Father chooses death so that the unborn one might live?"

"I have fear."

"Do you have the stone for painless childbirth?"

"*Saomete* put it in my hand at the ceremony of the first fruits. He leaves the stone with me and goes away. Now Father goes away."

"You have the symbol of *Atabei*, the All Mother, hanging from your neck."

"Will you be there?"

"Not in body, but I am there."

In the bowl of the turtle-shaped mortar she places the seeds and leaves and crushes them with the back of a parrot-shaped pestle. She places the powder in the small gourd he wears around his neck. The Boy finishes the feather mantle decorated with pearl beads and tying it around his shoulders, he turns in a circle from left to right before her.

11 October 1492 The Ocean Sea

At sunset I changed the course from WSW back to W. I do not know why. I gathered the men together for evening prayers. We said the *Pater Noster, Ave Maria* and the *Credo*. I led the men in the Litany of the Saints. After each intonation they chanted in Latin the response, "pray for us."

Sancta Maria — *ora pro nobis*
Sancte Joannes Baptista — *ora pro nobis*
Sancte Joseph — *ora pro nobis*

Omnes sancti Angeli et Archangeli — *orate pro nobis*
Sancte Michael — *ora pro nobis*
Sancte Gabriel — *ora pro nobis*
Sancte Raphael — *ora pro nobis*

Omnes sancti Patriarchae et Prophetae — *orate pro nobis*
Sancte Matthaee — *ora pro nobis*
Sancte Marce — *ora pro nobis*
Sancte Luca — *ora pro nobis*
Sancte Joannes — *ora pro nobis*

Omnes sancti Martyres — *orate pro nobis*
Sancte Damiane — *ora pro nobis*
Sancte Laurenti — *ora pro nobis*
Sancte Vincenti — *ora pro nobis*
Sancte Stephani — *ora pro nobis*
Sancte Sabastiane — *ora pro nobis*
Omnes sancti Innocentes — *orate pro nobis*

Sancta Agnes — *ora pro nobis*
Sancta Caecilia — *ora pro nobis*
Sancta Catharina — *ora pro nobis*
Sancta Lucia — *ora pro nobis*

Cristóbal Colón

At the dance plaza the people gather. Four poles are placed, one at each of the Four Pathways. Dressed in leaves and feathers and carrying branches and flowers they dance. The men, arms on the shoulders of the men on either side, move in one direction. Women, their arms resting on the shoulders of the women on either side, move in the opposite direction. Behind them and all around them in the forest beyond them, the spirits dance.

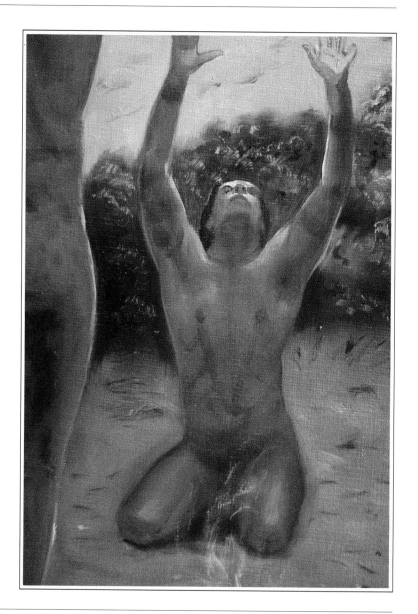

Dance of the Spirits

 Drum beat. Pipes sing.
 Shells clank. Gourds rattle.
 From left to right. From right to left.
 Dance the dance of the spirits.

The Boy steps forward, clothed in the feather mantle set with pearls. The singers and dancers repeat his chanted phrases and his steady movements.

 Trace the steps of *Saomete*
 Man of courage. Man of peace.
 From the heart of the Great South Land
 Along the Gentle Flowing River
 Out into the North Sea
 From the Little Island to *Boriquén*
 To *Aití*, home of the *Taino — Bohio*,
 Land of the fresh flowing rivers.

 Aití. Land of great chiefs.
 Hatuey, cacique of *Guahaba*
 Guarionex, cacique of *Maguá*
 Behechio, cacique of *Xaraguá*
 Cayacoa, cacique of *Higuey*
 Guacanagarí, cacique of *Marién*
 Caonabo, the Golden one, *cacique* of *Maguana*
 Husband of *Anacaona*, Flower of Gold.

 Life is gentle. Life is good.
 Trade with other islands in the North Sea
 Jamaica, land of woods and streams.
 Cuba, land of the wide valley.

 Dance the dance of tracing steps.
 Fly from the red men with swollen calves.
 Run from their poison arrows.

 Saomete takes us north.
 Takes *yocaiba* shoots and herbs,
 Healthful plants to grow again.
 Lucayos. Gentle islands. Our new home.

In the forest the spirits dance the dance. Father speaks to the Boy, the young master. "*Tequina*. Hear me. Heed this warning." The rhythm changes. Slowly, with reverence, he repeats the words in Father's voice.

 Never again sing the song
 Of the Long Long Past
 Never again sing the song
 Of the Long Past.

11 October 1492 The Ocean Sea

We sing the *Salve Regina*, each of us chanting after our own fashion, for mariners are fond of music.

Hail, Holy Queen, Mother of Mercy, hail, our life, our sweetness and our hope! To you do we cry, poor banished children of Eve! To you do we send up our sighs, in this vale of tears! Turn, then most gracious advocate, your eyes of mercy towards us; and after this, our exile, show unto us the blessed fruit of your womb, Jesus! O clement, O loving, O sweet Virgin Mary!

Cristóbal Colón

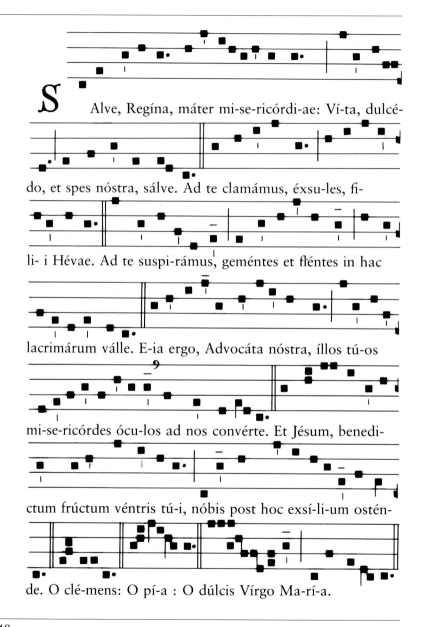

SAlve, Regína, máter mi-se-ricórdi-ae: Ví-ta, dulcé-do, et spes nóstra, sálve. Ad te clamámus, éxsu-les, fi-li- i Hévae. Ad te suspi-rámus, geméntes et fléntes in hac lacrimárum válle. E-ia ergo, Advocáta nóstra, íllos tú-os mi-se-ricórdes ócu-los ad nos convérte. Et Jésum, benedi-ctum frúctum véntris tú-i, nóbis post hoc exsí-li-um ostén-de. O clé-mens: O pí-a : O dúlcis Vírgo Ma-rí-a.

Night Songs

> Night songs sing of the day
> Beat the drum. Drink the wine.
> Dance to the rhythm of our singing.

The Child from the beadmakers' village moves behind the circle of men and the circle of women to offer wine from an owl-shaped vessel.

> *Chicha Chicha Chicha Chicha*
> Step in time. Step in time.
> Step together. Step. Step.
> *Chicha Chicha Chicha Chicha*

The Girl steps forward, big with child. The rhythm of her movements swings slow then fast. The others follow in perfect time. She sings.

The child leaps to life. Father leaps to death. Feel what I feel. Dance with me. This night I come upon a bird just born fallen from its nest. Or did the mother put it out? Why? Then I hear an owl nearby. Waiting, waiting for me to leave. In my hand the bird makes a little sound and opens its mouth wide to me. Why did I pick it up? It cannot live. One eye is bloody, its beak is broken. Still the cry and gaping mouth. The owl is watching, waiting. Leave it to the owl. Nature's way is best. But will death come quickly from the owl? Will the baby bird be frightened? It need not know of fear. In my hand, it is not afraid. I snap off the head with bloody eye and gaping mouth and bury it. The owl denied the pleasure of the kill, denied this bite of food, flies screeching off. If death must come I can do the killing.

The dance is frenzied now. The Girl big with child leaves the circle and goes into the wood alone. The men leave the women to their wild dancing. They go to the bluff to the *cohoba*. The Boy touches his naked chest and knows the weakness of the fledgling. He thinks about the Girl big with life going off alone to give birth to their child. He hungers to know what that feels like. Do other men ponder these things?

The feathers of his mantle tremble in the night breeze as he walks the path to the bluff. The moon is past full. The moon is the moon that ends the season of storms. This moon is three moons before the season of cold. Fires blaze and flare when the men place palmetto leaves on it.

The Boy is thinking. She holds the stone of painless childbirth and the spirits are within her circle. Still I wish to be near her, to help her struggle. Just as there is a struggle in death, there must be a struggle in birth.

11 October 1492 10 PM The Ocean Sea

Only the boys are asleep. All the men are watching. I take a sighting of Polaris. When I look back to the horizon, I see a light which looks like a wax candle rising and falling.

Cristóbal Colón

The men, faces painted red with *bija*, sit around the fire. Taking a stick from the embers, the Boy lights the special mixture of *cohoba* wrapped in corn leaves. He puffs and blows the blue smoke into the stars. To *huracán*, the Breath of Life, the Great Wind, the Heart of the Sky. Then he sends

49

smoke along the Four Pathways. Each man does the same as the *cohoba* is passed from left to right.

He pours the dust into the turtle-shaped bowl and using a forked reed sniffs the powder three times. The feather mantle weighs like stone upon his shoulders. He is warm inside. He can feel his blood running through his veins. The earth spins and the stars appear at his feet.

In his vision, a tall white man stands before him, silver spun in his golden hair. He holds a sceptre cut with many pictures. The tall man wears a long white robe strewn with red crosses like flowers. Pointing toward the east his blue-white eyes hold a warning. The Boy is drawn into those eyes and spinning through space he is hurled forward in time into a river overflowing its banks with his people. They are naked and frightened of the strange men wearing bright breast coverings and shiny pointed headdresses riding wondrous four-legged creatures which stamp about and splash the water. With sharp glittering sticks these white-skinned men slice off the heads of his people. Pouring water on their heads they make the sign of the Four Winds over them before cutting off their heads.

In another place, their dogs hunt his people and tear them to pieces. In yet another place he sees babies spitted on their sharp sticks and with arms and legs wriggling these warriors feed the babes to their dogs. A man is burning in a great fire built of spears. A hairless man, robed in the color of the earth stands before him holding two crossed sticks up to him. More of his people are spitted and roasted like *iguanas* over a slow fire.

In a *cacique* village he sees a radiant woman carried in a *hamaca* chair. Red and white flowers fall from her arms as she is brought before these strangers. Baskets of gold she sets before them. In another place and time this same woman is dragged to a dance plaza and hanged before her people. They shout in terror. *"Anacaona! Anacaona! Anacaona!"*

"Mother!"

In a remote place the Boy sees his people in despair jump from cliffs, drink the poison juice of the *yuca*, throw themselves onto sharpened sticks, club their children to death, and hang themselves from trees. Everywhere his people hang in trees.

The Girl does not see him. She stands over their sleeping child. Her arrow points at its back. Death is quick. She buries the child under a bitter *yocaiba* shoot. When he looks up he sees his wife hanging in a tree.

"No!"

How can this happen? Why does this happen? When is this happening? Flying among the stars, twisting and turning through levels of time and space he cries out for her. He finds her standing alone in the tall trees which line the beach on the west coast of *Guanahaní*. The white beach where she breathed life into him with the sweet water. How beautiful she is waiting there, golden in the early sun staring out to sea.

He looks out to sea. Just beyond the reef are large *canoas* riding high in the water. "Boats from the east," some say as they run to their canoes, to paddle out to greet them. "Men from heaven," other young men say as they go to trade with the white-skinned men on the beach.

Is this where it starts? Here at *Guanahaní*? He walks toward a tall man with white hair who is standing near a large cross his men are planting. His eyes are drawn to the top of the tall stranger's shiny stick. It forms a small cross and a snake twists around and up. The stranger smiles and reaches the stick to him. He grabs the blade and cuts his hand.

Writhing on the ground in front of the fire he screams out

all his warning, all his pain. The pain of children mauled and hacked, the pain of women raped and split, the pain of men skewered and roasted, the pain of earth clawed and scarred.

Empty of screams and terror, his lungs fill with smoke, the acrid smoke of burning flesh and the choking smoke of burning trees. The Girl unties the string around his throat and the smouldering feather mantle drops into the fire. Flames shoot high into the air, then die quickly.

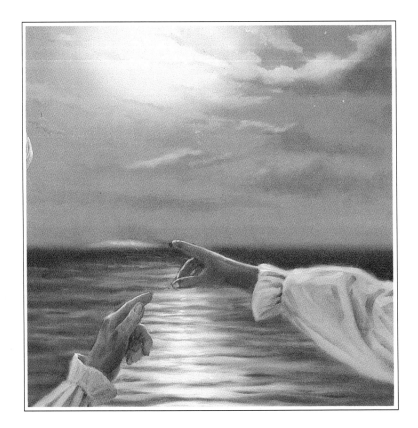

12 October 1492 2 AM Landfall

I look up at the stars to rest my eyes. *"Tierra! Tierra!"* Rodrigo de Triana shouts to me from the forecastle of the *Pinta*. I look and I see what appears to be a white sand cliff on the western horizon shining in the moonlight. Landfall. Thanks be to God.

I ordered sails to be lowered and all vessels to jog off-and-on until daybreak.

Cristóbal Colón

In the white bay under the bluff she washes herself and the child. On the beach he takes her bow and shoots an arrow into each of the Four Pathways. Looking at the mother, he sees specks of light trail from her small hands as she moves them about in the water. Lights of brilliant green-white and blue-white swirl about her and the child. Waves of color and light roll to the shore.

He walks into the star-filled sea and takes the mother and the child into his arms. "We must leave *Guanahaní.*"

"Where do we go?"

"See that blue star? We will build our nest in that star — the morning star."

Early sun

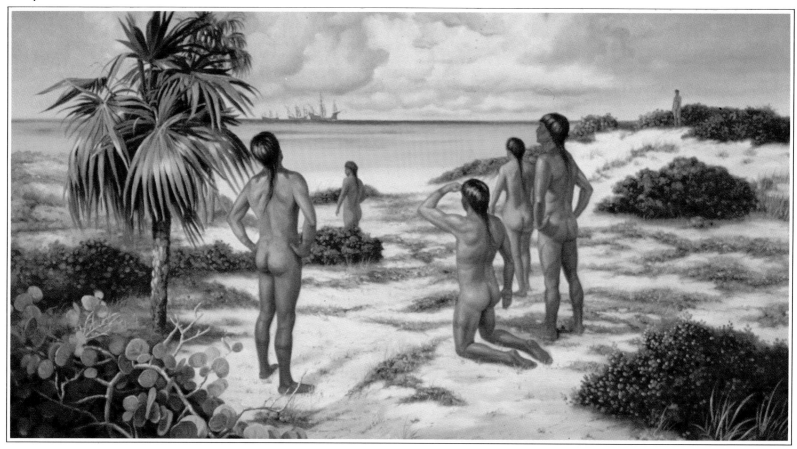

Historical Note

Columbus discovered America on October 12, 1492. This historical fact has stirred considerable debate over its effects on Western Civilization. It is pointless to dwell on Columbus' "discovery" when there were people already there to greet him. Clearly, he was not the first man to reach the "New World", and probably not even the first European. What is significant is that he opened trade routes between the Old World and a world new to 15th century Europeans. However, the most popular scholarly debate rages over which island in the Caribbean Columbus renamed San Salvador. The Bahamas government has decided that for the Quincentennial celebration of Columbus' First Voyage, the island presently called San Salvador is the one Columbus first sighted. The people who greeted him called their island *Guanahaní*.

As the first known historian of the West Indies, Columbus kept a *Journal* of his first voyage. It details his encounter with the Lucayan Indians. After remarking upon their nakedness, Columbus described their handsome bodies, broad foreheads, coarse hair, fine faces, handsome eyes and good stature. They were the color of the Canary Islanders, neither black nor white. The moment he set eyes on these people, Columbus decided that they would make good Christians as well as good servants. This is something Columbus probably thought Their Catholic Majesties King Ferdinand and Queen Isabella wanted to hear.

Bartolomé de Las Casas, a Dominican friar, chronicled the abduction of forty thousand Lucayans from the Bahamas to the mines in Hispaniola (Haiti and Santo Domingo). Later, when it was discovered what excellent swimmers the Lucayans were, they were taken to *Cubagua* to dive for pearls. They were *Tainos*, Island Arawaks, like those Indians of Haiti. *Lucayos* is the Arawak word for the Bahamas, the group of islands which stretch up from Haiti away from *Cuba* and towards Florida. *Lucayos* is also the Indian name for the people who inhabited those islands.

According to Las Casas, the Lucayans were by nature good people: patient, humble, peaceable, kind, generous and affectionate. During the forty years he lived at Haiti, he watched all of them die and described the hideous manner of their murders, and those of over a million other Island Arawaks, in his book, *The Devastation of the Indies*.

The Lucayans thought the Spaniards were taking them east to a mythical island where they would be reunited with their ancestors. As he sailed east from *Cuba*, Columbus' Lucayan guides pointed to Haiti and called it *Bohio* (a place of grand and happy houses). A twisted truth. They were being brought home in slavery.

Lucayans spoke soft melodious Arawak, the language of the people of the Orinoco in South America. Closer to Columbus' time, we can trace their movements east along the Orinoco River, out of its mouth to Trinidad, north through the Windwards, west along the islands of the Greater Antilles, then north into the Bahamas. Why these Indians emigrated to the Bahamas no one really knows for certain. Unlike the Caribs, the Lucayans did not like to fight. Columbus makes it clear that they had no proper weapons. However, they did fight when threatened. Spanish historian

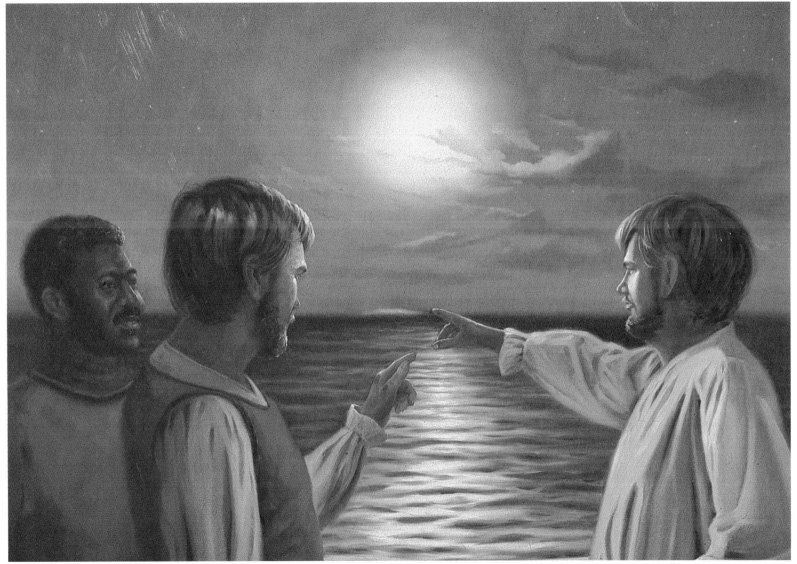

Discovery

Peter Martyr writes that when the Spaniards' intentions became clear to them, a few Lucayans killed a handful of soldiers with the bows and arrows they used for fishing. So earlier, when the Caribs staged raids upon the *Tainos* of Haiti, perhaps the Lucayans fled. There may have been some internal strife or their migration was simply a matter of population expansion.

Stretching back thousands of years, the question of the peopling of the Americas becomes even more complex. Traditional schools believe that the migration to the Americas was accomplished by means of a land bridge over what is now called the Bering Straits. Other schools, as early as the 19th century, believed that trade and the impetus for peopling Central America came from the Old World, the Phoenicians, the Egyptians, even the Atlantians. Architecture, customs and religion, suggest a connection between these two worlds long before Columbus arrived. The bearded, fair-skinned Quetzalcoatl is depicted as a Mexican world supporter like the figure of Atlas. Las Casas was perhaps the first historian to compare the Mayan temples in the Yucatan to the Egyptian pyramids. The Island Arawaks flattened their foreheads as did the Mayans and the Egyptians. Prehistoric peoples on both sides of the Atlantic believed in a monotheistic supreme being and the immortality of the soul. Sometimes they embalmed and sometimes cremated their dead; the Arawak dog deity, who took care of deceased souls, resembles Cerberus.

An inexplicable and curious birth custom occurred concurrently among the hill tribes of China, among the American Indians of the Mississippi Valley, among the Iberians of Northern Spain, in certain Brazilian cultures of South America, among some ancient people in France, among the Carians of the Mediterranean and the Caribs of the West Indies. When the mother gave birth, the father went to bed. There were cultural variations regarding the length of bed rest, fasting and hunting procedures, but the idea was basically the same. American Indians believed if an animal were killed when the child was an infant, the spirit of that animal would take revenge on the little one. For six months a Carib father would not eat meat or birds or fish. He believed what he consumed would either impress its likeness on the child or produce disease within the child.

The questions remain: when, how, and why did the Indians reach the west? Did they walk across the land bridge, down through Western North America into Central America and then into the Caribbean? Could there have been any migration from Polynesia to Peru and across South America into the Caribbean? Is there any truth in the legends that people migrated from Lemuria in the Pacific Sea or from Atlantis in the Western Ocean?

The Western Ocean was called the Atlantic after Plato's island city which lay beyond the Pillars of Hercules (the channel between the Mediterranean and the Western Ocean). According to Plato, Atlantis was destroyed by a cataclysm nearly 10,000 years before his own time. His detailed account even mentions a fruit having a "hard rind" that affords "drink and meats and ointments." Archaeologists and botanists still debate the date of the appearance of the coconut in the Antilles. The Indian word *coco* is even used today in Spanish to mean coconut. The Spanish lexicographer, Zayas y Alfonso, (Havanna 1914), remarks that the coconut was found in a wild state on islands and cays in the Caribbean in the early 1500's and it had industrial uses. Scholars will debate the issue until organic material can be found and dated back to prehistoric time.

Little is known about the lifeways of the Lucayans. Early

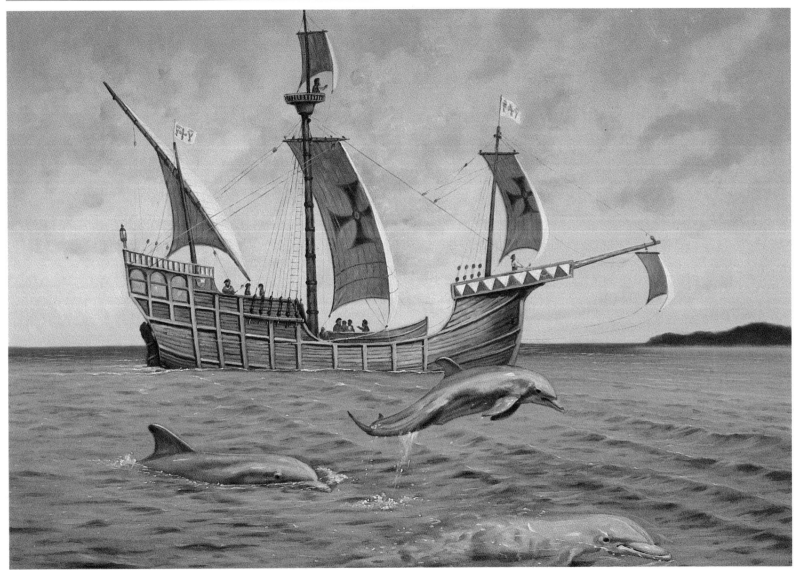

Nature's Pilots

Spanish historians, who traveled among the various Caribbean tribes, tried to learn what they could before the Conquistadors killed off the Indians. Fernández Oviedo wrote a natural history and Ramón Pane recorded myths and customs. Some information has come from *Taino* Indian descendants in Haiti, Santo Domingo, Puerto Rico, eastern *Cuba* (*Oriente*), and perhaps a few other scattered islands; there are no known descendants of the Lucayans in the Bahamas.

As archaeological work in the Bahamas escalates and methods improve, the more exciting the information about Indian lifeways becomes. Unlike the Spaniards, the Lucayans built permanent villages in the Bahamas. They constructed circular houses of wood and palm thatch. They believed, as did the North American Indians, that the power of the world works in circles and that everything in nature tries to be round. Each family possessed a house which was kept neat and clean. They may have used woven mat partitions, and put flat stones on the ground to keep utensils out of the dirt. They slept in hammocks (their word). Hut doors faced east to catch the rising sun.

Lucayan society was well developed. There was a chief (*cacique*). It is not certain whether each island in the Bahamas had a king; Columbus was directed to *Saomete* (Crooked Island) where King *Saomete* resided. He may have been the chief of the entire *Lucayos*. Chiefs sat on ceremonial stools called *duhos*, on which zoomorphic and anthropomorphic figures graced the front and geometric designs decorated the backs. Three *duhos* recently found in a cave on Long Island resemble one found at Turks Island some years ago. Caves were used by the Lucayans for ceremonies and burials.

Land was held in common. It seems that all prehistoric peoples believed that land could not be owned, only used, and that care had to be taken in its use, for to destroy the land would be to destroy themselves. Indians grew sweet potato (*aje*), corn (*maíz*), cotton, tobacco and the *yuca* root for bread they called *casabe*. Fire-hardened sticks were used to dig irrigation canals and to plant seeds deep in a mound of earth out of reach of birds. Young boys frightened the birds away from the fields. Women did the planting, for they knew how to bring forth life and taught it to the grain.

Lucayans spent their days gathering, hunting and fishing. Both Lucayan men and women used the bow and arrow. They hunted the rodent-like *hutía* and also the *iguana* with spears. They fished the manatee, turtle, shark, grouper, parrotfish and conch. They not only ate the conch meat, but also made tools and other utensils from the shell. The parrotfish must have been the particular favorite of one Lucayan on *Guanahaní*. Richard Rose, an archaeologist working through the Bahamian Field Station on San Salvador, found a limestone sculpture of a parrotfish at the Pigeon Creek Site. He conjectured that it was probably a *cemí* (religious image), and it looked like the thin stone heads found in Mexico and Guatamala. Archaeologist Steve Mitchell determined that the mounds of clam shells at the Pigeon Creek site on San Salvador were gathered during solstices which probably occasioned festivals. To prehistoric peoples all living things and places were sacred.

The Lucayans saw themselves as part of nature, not separate from it. They knew which herbs to use to cure ailments. In cooking they wasted little; all parts of fishes and animals were cut or ground up and cooked in a pot with spices and served with *ají*, a hot pepper condiment. Out of fish and animal bones, Indians fashioned spear darts, knives, scrapers, spoons, hoes and fish hooks. They used stingray spines for darts and barracuda and shark teeth for spears and

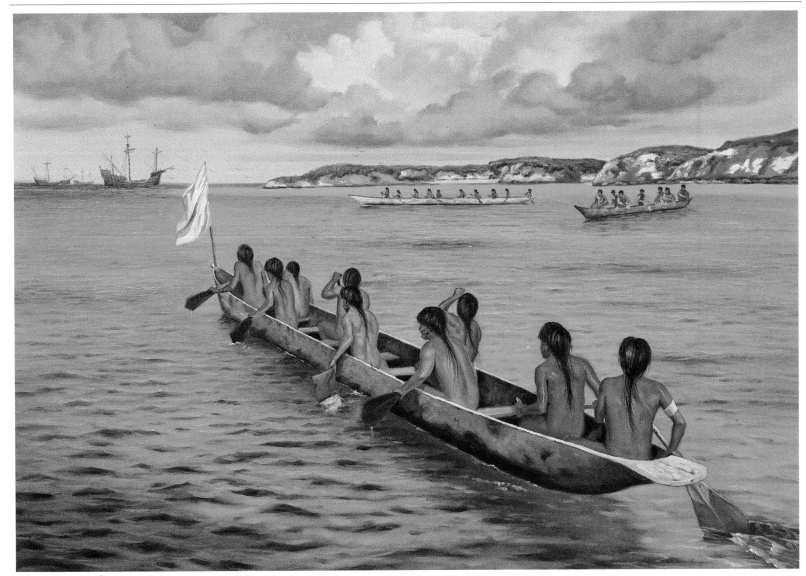

Lucayan Traders

arrows. They made sacks out of *iguana* skin.

The canoe played a fundamental role in Indian life. The Lucayan *canoa* was hand-hewn from a solid log and fashioned in all sizes to hold up to forty people. Their flat, thick bottoms took the waves well and once overturned were easily righted. The Indians bailed out excess water with calabashes. Both canoe and wide oars were crafted for swiftness and maneuverability. Canoes were used for reef fishing and trading. Lucayans traded actively and rowed long distances. They tamed parrots and used them for trade. A ceremonial bottle found at Abaco is made of clay found in North Florida. The jadite and serpentine material used to make ceremonial celts found in many of the Bahama Islands may come from as far away as Guatamala. Cotton was an important trade product, as were stone pestles and other utilitarian items.

Lucayan pottery (called Palmetto ware) is reddish in color. Because the Bahamian clay was inferior to the Antillian, it was tempered with bits of shell. Decorations appeared as mat marking, incised and punctated patterns. Lucayan pottery is not as decorative as Tainan pottery of Santo Domingo or Haiti. However, the artistry of the Lucayans is evident in their ornaments. A tiny flat bead, made from a conch shell, was found by Mary Jane Berman at the Three Dog site on San Salvador. A needle-thin hole was worked into the perfectly round bead — obviously the work of an artisan.

Archaeologist Theodoor de Booy found a linked cross or swastika pattern on pottery unearthed in the Caicos Islands in the early part of this century. According to Colonel Churchward the swastica (the Oriental and American Indian one, not the Nazi version which moves in the opposite direction) is the ancient symbol of the four great builders of the universe who bring order out of chaos. Not only were

there utilitarian reasons for their art but also metaphysical ones.

Arawaks believed that the sun was the great fire, the life force, the author of nature. The moon was the night sun, the mother goddess, the water goddess. Certainly there were rituals and ceremonies connected with planting. Dances lasted through the night and sometimes for days. On special ceremonial occasions the son of the *cacique* would recite the history of the king and his people.

The east was the great creative source. The Lucayans thought Columbus' men were children of the sun, the dawn, the light, because they came from the east, the home of their white ancestors. The Indians were mistaken. The Spanish cross was the symbol of the Christian religion, not the four great forces of creation, not even the four cardinal points. Lucayans exchanged gifts in friendship while Spaniards planted the cross to claim *Guanahaní* for the King and Queen of Spain, and renamed their island San Salvador (Holy Savior).

Las Casas wrote that there is no greater crime than that which is done under the mask of religion. He detailed the devastation of the Indies which followed in the wake of Columbus and speculated that if no gold had been found, the colonization of the Indies might have been a different story. Although he treated the Indians well, Columbus condoned slavery because he thought the Indians had no religion. However, since they gave their gold as freely as gourds of water, Columbus tried to protect them. He wrote to the King and Queen that, "No one who is not a Christian should come to these parts." Only Christians came, but they came to steal, to enslave and to murder.

Greed festers at the root of this tragedy. The Spaniards came for gold. They found it on Hispaniola, but not in the

Thanksgiving

Lucayos. King Ferdinand called the Bahamas "the useless islands" and authorized raiding parties resulting in the enslavement and death of forty thousand Lucayans. Blessing Their Majesties' endeavors was Rodrigo Borgia, Pope Alexander VI, a corrupt ecclesiastical politician. The Lucayans embodied Plato's theory of unconditional love. They practised what Joseph Campbell called "true religion," wherein you "love your enemies because they are the instruments of your destiny."

It is hoped that this five-hundred-year anniversary of Columbus meeting the Lucayans in the Bahamas can bring European, African, Caribbean countries and the Americas together in an atmosphere of peace and love for humankind.

This monument on San Salvador was placed through the efforts of Columbian scholar Ruth Wolper.

Explanation of Symbols

Colonel James Churchward spent fifty years trying to piece together the symbology that connected all humankind. He found its wellspring in the ancient continent of Mu (sometimes called Lemuria) located in the Pacific Ocean over 20,000 years ago. His three books: *The Lost Continent of Mu*, *The Children of Mu* and *The Sacred Symbols of Mu* provide a source for symbols which are painted on the bodies of the characters and the places referred to in the *areitos* (see glossary). I thank Richard E. Buhler of the Brotherhood of Life, Albuquerque, New Mexico for allowing me to share Mr. Churchward's work with you.

Symbols painted by the Girl on the Boy's body:

 Ancient concept of law and order carried throughout the universe by the butterfly. The elongated circle is the universe, space without end. The face is a circle with four discs. The circle is the Creator and the four discs represent the Sacred Four (Winds, Directions, Forces of Creation). Together they number five which is the number of the full Godhead. The two antennae represent law and order. In the wing the five bars symbolize the Godhead and the four spaces between the Sacred Four. The tongue, the symbol of speech, carries the Creator's command that law and order be established throughout the universe.

 The circle is the monotheistic symbol of the Deity. It is the sun symbol of the Infinite One.

 The square is the symbol of the earth, the cardinal points, the four corners, the Four Great Primary Forces. According to D. G. Brinton (*Myths of the New World*, 1896), the number four was a sacred number to prehistoric peoples of North America, South America and the Caribbean.

 One right angle means builder. Shown here are the Four Great Builders of the universe.

 The snake symbolizes water, the beginning of life and the power of creation. An adorned serpent is a popular ancient symbol for the Deity as Creator or the creative attribute of the Godhead. The seven headed snake symbolizes the seven stages of creation, the Seven Great Commands of Creation.

 The triangle represents the Triune Godhead and the Heaven where the Creator dwells.

 Going to somewhere.

 Coming from somewhere.

The simple cross is the ancient symbol of the Sacred Four, the Four Great Primary Forces.

 The Tau is the symbol of both resurrection and emergence, a springing to life and the rising of land above the water.

In the ancient writings of the Hindus, Babylonians and Egyptians these symbols read:

 The Creator is one.

 He is two in one.

 These two produced a son or man.

According to Laotzu (Chinese philosopher 600 B.C.), these symbols read:

 The Creator made one.

 One became two.

 Two produced three and so on.

This androgynous quality of the first being is discussed by Plato. In "Symposium," Plato states that man and woman were created combined in one body with four arms and four legs. This same androgeny appears symbolically in the Arawak legend of the creation of woman. The men were without women and one day they found snake-like creatures with arms and legs. The men decided to make these phallic creatures women by tying a woodpecker to each one. The bird thinking the creature a stick of wood bore a hole which became the female part.

Christopher Columbus used this symbol on his sketch of Hispaniola to indicate north. This sketch is the only surviving example of Columbus' cartography. All the journal entries in the novella are signed in Columbus' Spanish name — Cristóbal Colón.

Regarding the places referred to in the "*Songs of the Full Sun,*" the Lucayans would not use proper names but descriptive phrases.
The Land of the West (also called Land of the Sun) is Mu.
The Great Lake is the ancient Amazon which became the Great River.
The Great South Land is South America.
The Black River is the Negro River in South America.
The Gentle Flowing River is the Orinoco in South America.
The Great Land in the Western Ocean is Atlantis.
The Western Ocean is the Atlantic.
The City of Gold is Manoa, ancient city in South America.
The North Sea is the Caribbean.

Glossary of Indian Words

A Note on the Language and the Linguists

Dr. D. G. Brinton, writing in the last quarter of the 19th century, believed that the Arawak stock of languages was probably the most widely disseminated of any in South America. They extended from the headwaters of the Paraguay River up to the northern coast and concentrated on the Orinoco River.

Arawak speakers inhabited both the Greater and Lesser Antilles and the Bahamas, which brought the language within a short distance of the mainland of North America. English and Spanish speakers may find several familiar words. The authorities on the Arawak language are two Spanish linguists and historians: Bartolomé de las Casas, who was a missionary in Hispaniola for forty years, and Peter Martyr, who never came to America but spoke to the Indians brought to Spain by Columbus. Martyr found the Arawak language soft, "rich in vowels and pleasant to the ear" and an idiom "simple, sweet and sonorous." Both Bachiller and Zayas quote these two men and other Spanish historians in their dictionaries.

ABACO: Great and Little *Abaco* Islands in the northern Bahamas form the main of *Abaco* and together with the surrounding cays is called the *Abacos*.

AITI: The Indians had two names for this island, *Aití* and *Quisqueya* which signified hope and a great land. *Quisqueya* means whole earth, lush and mountainous. The sacred cave from which all creation sprang was located on this island. The Spaniards called it Hispaniola and today, the island has two parts: Haiti and the Dominican Republic.

AJE: The sweet potato.

AJI: Also *axí*. A hot pepper condiment. Las Casas said that the people of America used it on everything they ate, whether the food was roasted or boiled or raw. The Spaniards considered it healthy because the Indians, who were moderate in the use of "dangerous things" in their diet, used so much of this condiment.

ANACAONA: Her name is formed from *ana* meaning flower and *caona* meaning gold — i.e. flower of gold. She was sister of the Haitian King *Behechio* and wife of King *Caonabo*. After their deaths, she ruled as chief of the territory of *Xaraguá*. According to Zayas, when her brother *Mayobanex*, *cacique* of *Cyguayos* died, *Anacaona* asked her brother's wife *Guanatabenequena*, who was considered the most beautiful woman in all of *Aití*, to bury herself alive with her husband. It was the custom in *Aití* that the most beautiful and most loved woman of the chief should be buried alive with her dead husband.

Anacaona's people held her in high esteem for her poetic talent and great virtue. Las Casas knew her and said, "She was a

noteworthy woman, very prudent, very gracious, of great facility of speech and a good friend to the Christians."

On the pretext of repaying *Anacaona* for her many favors to the Spaniards, Ovando, tyrannical governor of *Aití*, went to *Xaraguá* with seven hundred infantry and seventy horse. *Anacaona* and three hundred of her nobles welcomed Ovando with festivities, dances and songs as was the custom. Many of the *areitos* (historical romances) were composed by *Anacaona*. On this particular occasion, three hundred women danced before the Spanish nobles. Ovando formulated a diabolical plot while he was honored for many days with the greatest simplicity and kindness. Telling *Anacaona* that he desired to show her nobles a cavalry charge in the European style, he surrounded the town, closing off all avenues of escape. All the people were burned along with the village and *Anacaona's* house. She was taken to Santo Domingo in chains where she was tried and hanged "in the presence of her people, who adored her."

AREITO: A traditional song and ritual dance. The Indians gave themselves passionately to dancing and thought of it as an occupation. Usually they formed circles. Sometimes the men and women danced separately, and at other times they danced together, each with the arms on the shoulders of the two adjacent people. They danced to their own singing, following the rhythm and mood of the *tequina* or master who could be a man or a woman. They drank *chicha*, a drink made from fermented corn.

Lyrics sometimes referred to the mythology and traditions of their people, included the genealogies of their chiefs or described events in their daily lives. Since they had no written language, they kept their history alive by reciting events of the past. Among the famous *areitos* mentioned by Zayas are the ones written by *Anacaona* for the visit of the Spaniards to her dominions in *Xaraguá*. Ironically, the five-line fragment Zayas quotes in his dictionary contains *Anacaona's* name; one phrase can be translated to read "let's be free."

ATABEI: Mother of God (*Yocahu*). The ending of her name means "she who proceeds from the principal." This mother goddess had five names which some scholars thought represented qualities of the Deity. Fra Ramón Pane, left by Columbus in *Aití* to collect the myths of the Indians, speaks of the five mothers from whom *Yocahu* had been born.

BAHAMA: The island of Grand Bahama in the *Lucayos*. Today the Lucayan Islands are called the Bahamas after this island in the group. What is ironic is that the archipelago bears an Indian name and not one Lucayan remains there.

BANANA: A species of *Plátano*. The naturalist, Fernández Oviedo thought that the *banana* was brought to the Caribbean from Spain. Other Spanish historians disagree and say that various species of the fruit are indigenous.

BARBACOA: The word means grilled meat. It was also a raised place used to store corn safely.

BEHECHIO: King of the province of *Xaraguá* in *Aití* and brother of *Anacaona*. Among his subjects, *Behechio* had thirty-two *caciques* and thirty wives. *Guanahata* was his favorite wife.

BIAYA: The flamingo, a long-legged, pink-feathered bird. The Indians would run after them, catch them and make a broth the color of saffron. The Spaniards found the meat as tasty as pheasant.

BIJA: The plant called *achiote* is used today in *Mexico* as a condiment. It is a small bush and the flowers come in bunches. The seeds are found in compartments inside a hairy pod about the size and shape of an almond as it appears on the tree. The seeds are sticky like tender wax. The Indians made balls with the seeds. To dye their skins red, they would rub these waxy balls on their faces and bodies. The dye had a strong odor and served as a mosquito repellent. The botanical name is *Vixa orellana*.

BIMINI: Two small islands in the *Lucayos*. The Indians told Ponce de León that a magic spring was located there. He went in search of this fountain of youth, missed *Biminí*, but found Florida which the Indians called *Cautió*.

BOHIO: Columbus' guide pointed in the direction of *Aití* and called it *Bohio* which is the Indians' generic name for their living quarters. Las Casas described their houses in *Aití* as round, made of sticks and straw (probably palm thatch) with bell-shaped roofs. There was a hole in the center of the roof to let the smoke out. Their houses were clean and the larger ones so pleasant that an emperor could live in one. The Indians called *Aití Bohio*, which means a place of grand and happy houses. Since the ancestors of the *Lucayos* came from *Aití*, the guide may have used the word to mean homeland.

BORIQUEN: The island of Puerto Rico. Columbus arrived there in November 1493. Zayas says that an old Spanish encyclopedia states the name means the land of the valiant, but the book did not say where that definition originated. *Bieque* is the little island very near the eastern end of Puerto Rico. Today it is called Vieques.

CACIQUE: Chief or leader of a tribe. A woman could also receive this distinction among her people.

CAICOS: The group of islands southeast of the Bahama chain. Geographically, they are considered part of the Bahama group. The Spaniards noted that these islands lie very close to the water and thought them dangerous to navigation.

CANOA: The Indian canoe was flat-bottomed, hand-hewn from a single tree trunk and could carry from one up to 150 people. These Indian vessels were capable of the tremendous speed and maneuverability necessary for traders to cover the long distances between islands. The canoe was long and narrow (some were as large as ninety-five palms) and of good form. The six-inch-thick flat bottom prevented capsizing and if one filled with water in a rain storm, the Indians bailed it out with calabashes. Columbus noted that the paddle resembled a "baker's peel" and was narrow at the tip to cut the water. The Indians filed their oars with the rough skin of a man-eating shark. The *canoa* can turn 360 degrees; the rower at the stern acts as a rudder.

CAONABO: The Golden One. Since he was *cacique* of *Maguana* in the heart of *Aití*, he was sometimes called the golden house or place where gold is abundant. Some sources say he was a native of the *Lucayos*. After his death, his wife, *Anacaona* succeeded him as ruler of *Maguana*.

Caonabo was the first American to fight against the Spanish invaders. Columbus' vessel, the *Santa María*, was wrecked at Cap Hatien on Christmas Day 1492 and he was forced to establish a fort there called Navidad. He left behind thirty-nine men and when a few of them wandered into *Caonabo's* territory, *Caonabo* had them killed. He then marched on the fort, killing all the Spaniards and burning the village. Later, *Caonabo* with ten thousand men attacked another fort. But, even with his superior numbers, he was forced to retreat; his arms did not equal those of the Spaniards.

Columbus offered this humorous strategy to capture *Caonabo*. Somehow the *cacique* must be trapped and forced to put clothes on, so that if he should run away, a soldier might have something to grab. The agile soldier Alonso de Hojeda apprehended *Caonabo*. Although he was very capable of doing so, Hojeda did not have to chase the *cacique*.

The Indians loved the brass and steel used by the Spaniards. They called it *turey* which means sky or the shine of the sky or the sun. One of the reasons the Indians thought the Spaniards came from the sky was their shiny adornments. Hojeda invited *Caonabo* to make peace and promised the *cacique* a prize. When *Caonabo* arrived, Hojeda produced manacles made of shining steel — metals from Viscaya engraved with the arms of the kings of Castile, the

conquistador told *Caonabo*. He offered to dress *Caonabo's* wrists and feet with ornaments in the same manner that the king would wear them. Of course, the *cacique* could not refuse such a precious gift. Once chained, *Caonabo* was imprisoned in the hold of a galleon for several months. A storm came up before the ship could set sail for Spain; *Caonabo* and six hundred men were drowned. The Spaniards established a town where *Caonabo* was captured. It was called the villa of San Juan de la Maguana.

CASABE: The bread made from the *yuca* and the staple food of the Indians. Sometimes the bread was dipped in water seasoned with *ají*. Las Casas writes that the women made the bread and as they grated the root, they "sang a song that had a nice tune."

A poisonous juice had to be extracted from the grated flour before the bread-making process could continue. Some Indians, weary of their enslavement in the mines of *Aití*, drank this juice as one form of suicide.

CAYACOA: King of the *Higuey*. His widow was baptized Doña Inéz de *Cayacoa*.

CEMI: Also *semí* and *zemí*. A religious image of wood or stone made in the likeness of a human figure, an animal or a vegetable. Some had special faculties. A *cemí* might be used to bring rain or to assist in childbirth. The three pointed stones, usually the representation of *Yocahu*, the Great Deity, were buried in the earth to help the crops grow. The Indians carved personal *cemís* and wore them for protection. According to Dr. Julian Granberry's linguistic study of the word, it means spirit.

CHICHA: A wine made from fermented corn.

COCO: The fruit called the coconut. Historians and archaeologists debate whether the coconut is indigenous to the islands of the Caribbean. Some Spanish historians write that in the 1500's coconut trees were found in a wild state on islands and cays in the Caribbean. According to Zayas, the word is of Greek origin. The Greek word koyki describes this plant.

COHOBA: Name of the plant, the leaves of which the Indians smoked or crushed to produce a narcotic effect. The Spaniards called the plant *tabaco* after the pipe the Indians used to inhale the powder.

The plant stood four or five palms high and had wide, thick, soft, hairy leaves. The Indians made cigars by wrapping crushed *cohoba* leaves in a dry leaf; they then lit the roll and inhaled the smoke. The crushed *cohoba* leaves were mixed with powders of other herbs and sniffed up from a bowl through the *tabaco*. Las Casas writes that herbal powders the color of cinnamon were placed in a smooth, black shiny bowl as beautiful as gold or silver. The instrument for sniffing the powder was hollow and forked and made from the same wood. The forked end was placed in the nostrils and the single tube in the bowl. This *tabaco* was sometimes decorated with gems or gold leaf.

The ceremony of absorbing the smoke or powder was also called *cohoba*. The Indians would sit and discuss important issues and speak to the *cemís* to get answers to their questions. Las Casas noted that the effect produced was like being intoxicated and sometimes the Indians seemed to lose their senses and consciousness. The Indians said they sometimes went into a trance state where they saw "a thousand visions."

CUBA: Columbus died thinking that this island was mainland China. Sven Loven (*Origins of the Tainan Culture*, 1935) states that the pre-Arawak tribe, the *Guanahatabeyes* lived in western *Cuba* in caves and lived hand to mouth. They held all property in common except wives. According to the Indians of *Aití*, the *Ciboneys* arrived in *Cuba* about fifty years before Columbus. Loven believes that the *Ciboneys* came from Florida. Zayas writes that relations between *Cuba* and *Cautió* (Florida) were established

early. Indians from *Cuba* built the town of *Abaibo* in Florida. They had come looking for the Fountain of Youth. The Indians of *Aití* held the same tradition, but they believed the healthful waters were located in *Bimini*. According to Antonio Herrera, appointed by King Philip II to be chief historian of the Indies in 1596, Southern Florida was settled by the Lucayan Indians. They covered their loins with plaited palm. According to Dr. Granberry, *cautió* was the Indian name for that covering.

CUBAGUA: An island near Marguerita off the north eastern part of South America famous for its pearl beds. The Lucayans were not suited for the plantations or the gold and silver mines of *Aití*. However, they were excellent swimmers and although the going price for slaves was four pesos, the Spaniards sold the Lucayans for 150 gold pesos.

In his *Brief Account of the Devastation of the Indies*, Las Casas relates the excruciating experience of the Lucayans at *Cubagua:*

> The pearl fishers dive into the sea at a depth of five fathoms (thirty feet), and do this from sunrise to sunset, and remain for many minutes without breathing, tearing the oysters out of their rocky beds where the pearls are formed. They come to the surface with a netted bag of these oysters where a Spanish torturer is waiting in a canoe, and if the pearl diver shows signs of wanting to rest, he is showered with blows. . . .
>
> Often a pearl diver does not return to the surface, for these waters are infested with man-eating sharks . . . that can kill, eat, and swallow a whole man.
>
> . . . And in this extraordinary labor, or better put, in this infernal labor, the Lucayan Indians are finally consumed. . . .

Ironically, the word *Cubagua* means "without water."

DUHO: A ceremonial seat made of wood or stone carved in images both anthropomorphic and zoomorphic. Often the ears and eyes of the animals were made of gold.

EXUMA: One of the islands and groups of cays in the Bahamas sighted by Columbus on his first voyage.

GUACANAGARI: King of *Marién* in *Aití*, situated in the area of Cap Hatien where the *Santa María* was wrecked on Christmas Day 1492. *Guacanagarí* and his people helped Columbus salvage his supplies from the vessel before it broke up on the reef. The chief took Columbus to his village and gave him two of his best houses. Columbus established the first Spanish settlement in America there and called it La Navidad. The Admiral left behind thirty-nine men to garrison his new fort. When he returned eleven months later, the men had been killed and the village burned.

The depraved conduct of the Spaniards brought the wrath of the Indians. *Caonabo* and his men destroyed the fort. *Guacanagarí* claimed to have fought on the side of the Spaniards. Always on the side of the Indians, Las Casas considered him a traitor to his country.

GUAHABA: Province in *Aití* ruled by chief *Hatuey*.

GUANAHANI: The island in the Bahamas Columbus named San Salvador. Despite the scholarly disputes over the centuries, the Bahamas government has decided that for the purposes of the Quincentennial celebration that the island presently named San Salvador is the land Columbus first sighted in America. It is the hope of this writer that the island's name be restored to *Guanahani* in honor of the Lucayans, those first Bahamians, whose spirit filled the Bahama Islands five hundred years ago.

GUANIMA: Zayas identifies this island as Eleuthera in the Bahamas. According to the Turin map, circa 1523, *Guanima* is Cat Island and *Ziguateo* is Eleuthera.

GUARIONEX: King of *Maguá* in *Aití*. *Guarionex* was apprehended along with fourteen other *caciques* who led an insurrection against the Spaniards. Only two *caciques* were punished. *Guarionex* and the others were released. In return for this gesture of good will, the Spaniards had peace, but only for a few days. The Indians attacked again.

When Columbus returned to *Aití*, he sent his brother to quiet the rebellion. Six thousand naked Indians painted in various colors, but with little weaponry, were forced by the Spaniards to retreat to the woods where they were soon captured. *Guarionex* was chained in the same ship with *Caonabo*. A hurricane sank the vessel in the port at Santo Domingo. Everyone died.

GUAYABA: The fruit that in English is called Guava. Oviedo thought the tree, with its hard resistant wood, was pretty and the bloom fragrant. The leaves were used to smoke meat.

HABACOA: The Berry Islands in the Bahamas.

HAMACA: A hammock. The Indians used it for sleeping and for transporting their chiefs from one place to another. Hammocks were usually made from *cañamo*, the rope of the *henequén* plant and stronger than cotton.

HATUEY: *Cacique* of *Guahába* in *Aití*. He escaped after *Anacaona* was hanged and fled to *Cuba* to warn the people about the Spanish. He organized a resistance to fight Diego Velázquez who was beginning to occupy *Cuba*.

Thinking that gold was the god of the Spaniards, he ordered all the gold to be thrown in the river. Then he and his people sang and danced an *areito* in the hope of appeasing this god. Their prayers were futile. *Hatuey* sent the women and children into the hills and attacked the Spaniards whose superior arms, once again, vanquished the Indians.

Hatuey was burned at the stake. Las Casas writes that when the Franciscan friar in attendance asked *Hatuey* to accept the religion of the Spaniards so he would go to heaven and avoid the fires of hell, the chief replied that if the Spaniards went to this heaven, he preferred to go to the other place. Elderly Cubans, who know the story, like to believe that *Hatuey* also said, "This land will never be free." Certainly he is the champion of the oppressed peoples of the Caribbean countries.

HENEQUEN: This is the plant whose strong fibres (*cañamo*) are used for rope, hammocks and nets. Its botanical name is *Cocus nucifera*.

HIGUEY: Territory ruled by King *Cayacoa*. The people of this province were war-like. They used poison arrows like the *Caribs*, who, by 1470 had occupied much of *Samana*, the peninsula just above this province in *Aití*.

HURACAN: A storm with strong winds. According to Brinton, the Great Breath called *Huracán* was thought of as a creative force and was considered the heart of the sky.

HUTIA: Also *agoutí*. The *hutía* is a small quadruped found in the islands of the Caribbean and the Bahamas. It seems to be a species in-between the rabbit and the rat. A staple food for the Lucayans, it is almost extinct today.

IGUANA: A reptile of great size with an indented crest running from its head down its back. The animal is fearful to look upon, but quite harmless. Oviedo says that the "animal is better to eat than to see. Very few people who have seen it have dared to eat it." The white meat had a delicate flavor which the Spaniards loved.

INAGUA: One of the islands in the Bahamas.

JAMAICA: It is one of the four major islands in the Greater Antilles. Its name means land of abundant springs.

LUCAYOS: This group is called the Bahamas today, named after one of their islands in the northern reach of the archipelago situated between Florida and *Abaco*. The group is north of *Cuba* and *Aití*. *Lucayos* was also the Indian name for the people who inhabited these islands.

Las Casas described the Lucayans as naturally good, and peaceful. They had the same gentle temperament as the Indians of the little cays attached to the north and south of *Cuba*. One string of cays was called The Garden of the King and the other The Garden of the Queen. Bachiller said the *Lucayos* had not been bothered by the war-like *Caribs* because the Lucayans had given to them the island of *Ayay* in order to be left alone.

The popular estimate of their numbers is 40,000 "souls". Ovando convinced King Ferdinand that it would be easier to "civilize" the Lucayans and instruct them in the true religion if they were moved to *Aití* and put under the supervision of the missionaries. Ovando told the Lucayans that he was taking them east to the land of their forefathers. They went peaceably, anxious to be reunited with their ancestors. Instead they "united their moaning and tears" with those damned to inexplicable cruelties.

MAGUA: Province in *Aití* governed by the *cacique Guarionex*. The Spanish named this territory La Vega Real which describes a low land which is flat and fertile.

MAGUANA: Province in *Aití* ruled by *Caonabo*. Its fertile land is both beautiful and healthy.

MAHOGANI: This word was used to designate the wood of the *caoba*, which is a large tree, sometimes thirty feet high and twelve feet in diameter. The Indians used the trunks of these trees to make their canoes. The botanical name is *Swietenia mahogani*. In the islands today the mahogany tree is called madeira which is like the Spanish word for wood (madera).

Another large tree used for making canoes was the *ceiba*. Its trunk is thick and its branches strong. Brinton states that the Indians considered the tree sacred because its limbs stretched to the four winds and its roots dug into the waters. The *ceiba* blooms every four years and inside these capsules a soft silky material wraps the seeds. Today the *ceiba* is commonly called the silk cotton tree.

The Indians also used cedar for canoes and a wood they called *maría* which grew along the coasts of Puerto Rico and was considered sacred.

MAIZ: The corn of the Americas. It was abundant everywhere, even in Florida. The Indians cooked it in water, then ground it and roasted the grains wrapped in corn leaves. Las Casas said the Indians used the grains "to count the Spaniards and *appreciate* their numbers [italics mine]."

MANATI: An aquatic mammal of great size which eats grass near the banks of rivers. It is commonly called a sea cow and has thick skin like a whale and no scales. Columbus thought they were mermaids. The Spaniards ate the manatee on Fridays and could believe they were eating meat. To them, it tasted like good veal.

Las Casas tells a story of a domesticated manatee called *Mato* which means magnificent. The Hatian *cacique Caramateji* caught a young manatee, raised it and kept it twenty-six years in the river which ran by his village. *Mato* was so tame and so friendly he would come out of the water and play with the children and eat in people's houses. His size and strength enabled him to ferry ten people at a time across the river. The Indians loved to play with him and *Mato* especially enjoyed it when the people sang.

One day a Spaniard came to the village to see if *Mato's* skin was as thick as people said it was. He called to *Mato* and when the manatee came out of the water, he threw a spear at him. Although *Mato* was not wounded physically, his feelings were hurt. After that time, he would not come out of the water if there was a clothed, bearded man about, even if he were called. One year the River

Atibonico rose so high that the currents carried *Mato the Magnificent* out to sea which saddened *Caramateji* and his subjects.

MARIEN: The province in *Aití* governed by *Guacanagarí*. In his *cacique* village Columbus established his first settlement. Zayas writes that from the mountains to the sea, gracious and happy rivers descend and the valleys have good land for cultivation. There were mines of copper in the mountains. In these days of Spanish occupation, one gold peso could buy one pound of copper.

MATININO: Mythical island of women. The Indians told Columbus of an island that had much gold and only women. The men visited once a year for breeding purposes. The female children were allowed to remain on the island, but the male children were sent to the island of men. In this respect the Indian story is similar to the Greek myth of the Amazons.

In spite of the lure of gold, Columbus never went to this island. Historian Martín Fernández de Navarette thought *Matinino* was St. Lucia. Washington Irving thought it was Martinique. However, the Island *Caribs* knew Martinique as *Ionacaera*. In the late 16th century a Spanish document stated an island named *Martinino* was one of the islands of the *Lucayos*.

MAYAGUANA: One of the Bahamas.

PAPAYA: The plant has a straight trunk with only a few palm-like leaves at the top. Its fruit is considered medicinal and is applied to stomach ailments. The botanical name is *Carica papaya*. In English it is called papaw.

SAMANA: One of the Bahamas. It is south of *Guanahaní* and lately considered to be Columbus' island of landfall by Joseph Judge. According to the Juan de la Cosa map of 1500, *Samana* is Long Island.

SAOMETE: King of the *Lucayos*. It is the Indian name for Crooked Island in the Bahamas where *Saomete* resided.

TAINO: Tribe of peaceful Arawak speakers in the Greater Antilles and the culture stock of the Lucayans. The word means noble and good. According to Bachiller, the *Tainos* numbered 1,200,000 inhabitants in *Aití*, 600,000 in *Cuba*, 100,000 in *Boriquén* (Puerto Rico), 60,000 in *Jamaica* and 40,000 in the *Lucayos* to the total population of two million.

TEQUINA: A master or shaman. The word is also applied to any man or woman cunning in any science: fishers, fowlers, hunters and makers of nets.

XARAGUA: Also *Jaraguá*. Province in *Aití* governed first by *Behechio* then by his sister *Anacaona*. According to Loven, the province grew a fine quality cotton. The manners and customs of the people of *Xaraguá* were refined and their speech aristocratic.

YUCA: The edible root of the *yucaiba*, from which *casabe* is made. This bread was not only a staple food for the Indians, but the Conquistadors also took it along on their expeditions. *Anaiboa* is the flower of the *yuca* and its botanical name is *Jathropa manihot*.

YUCAIBA: The plant whose root is used in the production of *casabe*, the bread of the Indies.

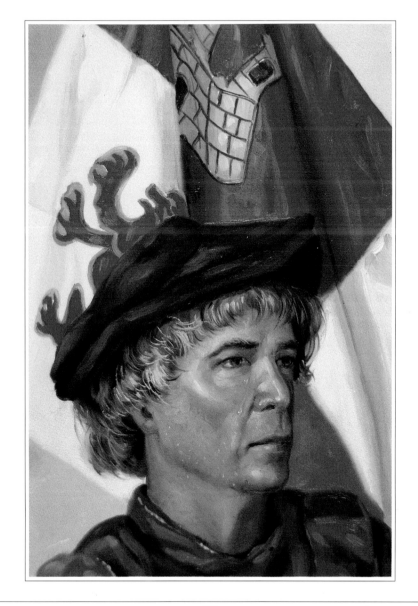

Thanksgiving

Sources

Adams, Beatrice Wolper. *Horticulture of San Salvador Island*. San Salvador, Bahamas: New World Museum Publication, 1975.

Berman, Mary Jane. Personal Interview. 12 June 1988.

Bierhorst, John, ed. *The Red Swan: Myths and Tales of the American Indians*. New York: Farrar, Strauss and Giroux, 1976.

Bourne, Edward Gaylord. "Columbus, Ramón Pane and the Beginnings of American Anthropology." *Proceedings of the American Antiquarian Society* 17 (1906): 310–348.

Brinton, Daniel. "Arawak Language of Guiana in its Linguistic and Ethnological Relations." *Transactions of the American Philosophical Society* 14 (1971): 427–444.

___. *Essays of an Americanist*. Philadephia: David McKay, 1890.

___. *The Myths of the New World*. Philadephia: David McKay, 1896.

Brown, Tom Jr., with Brandt Morgan. *Tom Brown's Field Guide to Wilderness Survival*. New York: Berkley Books, 1983.

Brown, Tom Jr. *The Vision*. New York: Berkley Books, 1988.

Campbell, David. *The Ephemeral Islands: A Natural History of the Bahamas*. London: Macmillan Caribbean, 1978.

Campbell, Joseph with Bill Moyers. *The Power of Myth*. Edited by Betty Sue Flowers. New York: Doubleday, 1988.

Carr, Robert S. and Sandra Riley. "An Effigy Ceramic Bottle from Green Turtle Cay, Abaco." *"The Florida Anthropologist 35* (1982): 200–202.

Churchward, Col. James. *The Children of Mu*. Albuquerque: BE Books, 1988.

___. *The Lost Continent of Mu*. Albuquerque: BE Books, 1987.

___. *The Sacred Symbols of Mu*. Albuquerque: BE Books, 1988.

Curry, Robert A. *Bahamian Lore*. Paris: Printed Privately, 1928.

DeBooy, Theodoor. "Lucayan Artifacts from the Bahamas." *American Anthropologist* 15 (1913): 1–7.

Donnelly, Ignatius. *Atlantis: The Antediluvian World*. New York: Dover Publications, Inc., 1976.

Drummond, Lee. "The Serpent's Children: Semiotics of Cultural Genesis in Arawak and Trobiand Myth." *American Ethnologist* 8 (1981) : 633–60.

___. "Structure and Process in the Interpretaion of South America Myth: The Arawak Dog Spirit People." *American Anthropologist* 79 (1977) : 842–868.

Eden, Richard, trans. *The Decades of the Newe Worlde or West Indies*. By Pietro Martire d'Anghiera. London: NP, 1555.

"Expedition by Canoe from the Amazon to the Caribbean." A Symposium. Bahamian Field Station, San Salvador, Bahamas. 19–21 June 1988.

Frye, John. *The Search for the Santa Maria*. New York: Dodd, Mead and Co., 1973.

Granberry, Julian M. "A Survey of Bahamian Archeology." Thesis. University of Florida, 1955.

Hoffman, Charles. "Archaeological Investigations at the Long Bay Site, San Salvador, Bahamas." *First San Salvador Conference: Columbus and His World*. Compiled by Donald T. Gerace. San Salvador: Bahamian Field Station, 1987. 237–245.

___. "Bahama Prehistory: Cultural Adaptation to an Island Environment." Diss. University of Arizona, 1967.

___. "The Palmetto Grove Site on San Salvador, Bahamas." *Contributions to the Florida State Museum*. Social Science, Number 16. Gainesville: University of Florida 1970.

Judge, Joseph. "Where Columbus Found the New World." *National Geographic* 170 (1986): 566–572, 578–599.

Keegan, William F. "Horticulturalists: Population and Expansion in the Prehistoric Bahamas." Diss. UCLA, 1985.

___. "Lucayan Fishing: An Experimental Approach." *The Florida Anthropologist* 35 (1982): 146–161.

___. "New Directions in Bahamian Archaeology." *Journal of the Bahamas Historical Society* 10 (1988): 3–8.

Krieger, Herbert W. *Aboriginal Indian Pottery of the Dominican Republic.* U.S. National Museum Bulletin 156. Washington, D.C.: Smithsonian Institution, 1931.

Las Casas, Bartolomé de. *The Devastation of the Indies: A Brief Account.* Translated by Herma Briffault. New York: The Seabury Press, 1974.

___. *History of the Indies.* Translated and edited by Andrée Collard. New York: Harper and Row, 1971.

Leach, Edmond. "Lévi Strauss in the Garden of Eden: An Examination of Some Recent Developments of the Analysis of Myth." *Transactions of the New York Academy of Sciences* 23 (1961): 386–396.

Loven, Sven. *Origins of the Tainan Culture, West Indies.* Göteborg 1935. USA: AMS, 1979.

Mitchell, Steven W. "Analysis of Tidal Growth Sequences in Populations of *Codakia Orbicularis* (Linnaeus) from the Lucayan Arawak Pigeon Creek Site, San Salvador." *Bahamas Archaeological Project Reports and Papers.* San Salvador, Bahamas: Bahamian Field Station, 1980. 1–20.

Montas, Borrell. *Arte Taino.* Santo Domingo: Central Bank of the Dominican Republic, ND.

Morison, Samuel Eliot. *Admiral of the Ocean Sea: A Life of Christopher Columbus.* Boston: Little, Brown and Co., 1942.

Neihardt, John G. *Black Elk Speaks.* New York: Pocket Books-Washington Square Press, 1959.

Ober, Frederick. "Aborigines of the West Indies." *American Antiquarian Society* 9 (1894): 270–313.

Olsen, Fred. *On the Trail of the Arawaks.* Norman: University of Oklahoma Press, 1974.

Oviedo, Gonzalo Fernández. *Natural History of the West Indies.* Translated and edited by Sterling A. Stoudemire. Chapel Hill: University of North Carolina Press, 1959.

Plato. "Critias." *The Dialogues of Plato. The Great Books.* Vol. 7. Translated by Benjamin Jowett. Chicago: Encyclopaedia Britannica, Inc., 1952. 478–485.

___. "Symposium" *Dialogues of Plato.* The Jowett Translation. New York: Washington Square Press, 1950. 161–234.

Prescott, W. H. *The Conquest of Mexico.* Vol. 1 New York: E. P. Dutton and Co., 1909. 2 Vols.

Priego, Joaquin R. *Cultura Taina.* Santo Domingo: Publicaciones America, 1977.

Rose, Richard. "Lucayan Lifeways at the Time of Columbus." *First San Salvador Conference: Columbus and His World.* Compiled by Donald T. Gerace. San Salvador: Bahamian Field Station, 1987. 321–339.

___. "The Pigeon Creek Site, San Salvador, Bahamas." *The Florida Anthropologist* 35 (1982): 129–145.

Rouse, Irving. "The Arawak" and "The Carib." *Smithsonian Bureau of American Ethnology Bulletin 143: Handbook of South American Indians.* Ed. Julian H. Stewart. 4 (1948): 522–545, 546–565.

___. "The Olsen Collection from Ile à Vache, Haiti." *The Florida Anthropologist* 35 (1982) : 169–185.

Saur, Carl. *The Early Spanish Main.* Berkeley: U of California Press, 1966.

Sears, William H. and Shaun O. Sullivan. "Bahamas Prehistory." *American Antiquity* 43 (1978) : 3–25.

Smith, Rhea M. "Anthropology in Florida." *Florida Historical Society* 11 (1933) : 151–172.

Spalding, Baird T. *Life and Teaching of the Masters of the Far East.* Marina Del Rey, California: DeVorss and Co., 1964, 1972, 1962, 1976, 1955. 5 vols.

Spence, Lewis. *Atlantis Discovered.* New York: Causeway Books, 1974.

Statnekou, Daniel K. *Animated Earth.* Berkeley, California: North Atlantic Books, 1987.

Tavares, Juan Tomás. *Los Indios de Quisqueya*. Santo Domingo: Editora de Santo Domingo, 1976.

Tedlock, Dennis, trans. *Popol Vuh: The Mayan Book of the Dawn of Life*. New York: Simon and Schuster, Inc., 1985.

Winter, John. "San Salvador in 1492: Its Geography and Ecology." *First San Salvador Conference: Columbus and His World*. Compiled by Donald T. Gerace. San Salvador: Bahamian Field Station, 1987. 313–320.